The art of

DESIGN

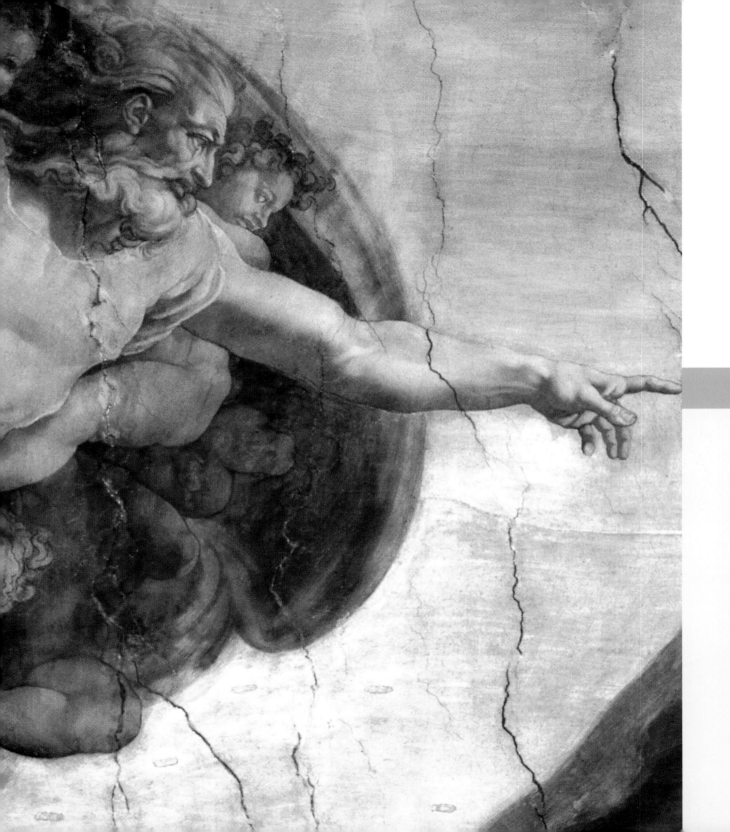

The art of

HOW
DESIGN BOOKS
Cincinnati, Ohio
www.howdesign.com

DESIGN

[CHERYL DANGEL CULLEN]

inspired by *fine art,* illustration and FILM

The Art of Design. © 2003 by Cheryl Dangel Cullen.
Manufactured in China. All rights reserved. No other
part of this book may be reproduced in any form or by
any electronic or mechanical means including informa-
tion storage and retrieval systems without permission
in writing from the publisher, except by a reviewer,
who may quote brief passages in a review. Published
by HOW Design Books, an imprint of F&W Publications,
Inc., 4700 East Galbraith Road, Cincinnati, Ohio 45236.
(800) 289-0963. First edition.

07 06 05 04 03 5 4 3 2 1

EDITOR: Amy Schell
COVER DESIGN: Lisa Buchanan
INTERIOR DESIGN: Brian Roeth
PAGE LAYOUT: Kathy Bergstrom
PRODUCTION COORDINATOR: Sara Dumford
PHOTOGRAPHER: Christine Polomsky
COVER AND TITLE PAGE ART: Sistine Chapel,
 Vatican, Rome/SuperStock

Library of Congress Cataloging-in-Publication Data
Cullen, Cheryl Dangel.
 The art of design : inspired by fine art, illustration,
and film / Cheryl Dangel Cullen.--1st ed.
 p. cm
 ISBN 1-58180-337-0 (alk. paper)
 1. Commercial art--History--20th century--Themes,
motives. 2. Graphic arts--History--20th century--
Themes, motives. 3. Creation (Literary, artistic, etc.) I.
Title.

NC998.4.C846 2002
741.6'09'04--dc21
 2002027298

The credits on pages 143–144 constitute an extension
of this copyright page.

[DEDICATION]

To all the designers who contributed to this book, inspiring me to greater heights with their creativity; and to those who have become more than just contributors, but friends as well.

To my family and friends who have supported me through a challenging year and are with me to see the light at the end of the tunnel.

To all of you, I extend my deepest and sincerest appreciation.

CDC

[contents]

> INTRODUCTION ... 8

SECTION ONE

designs inspired by fine art ... 10

SECTION TWO

designs inspired by illustration ... 58

SECTION THREE

designs inspired by film, photography & cinematography ... 100

COMPILATION OF INSPIRATIONS ... 138

CONTRIBUTORS ... 141

COPYRIGHT AND PERMISSIONS ... 143

[INTRODUCTION]

"What inspires you?"

"Where do you turn when your ideas run dry?"

"What do you do when you face the total intimidation of a blank canvas?"

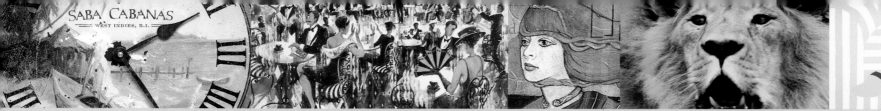

These are just a few among the many questions posed to designers from around the world—successful designers who have had their share of projects that begged for something more, something with the potential to make an ordinary project soar to extraordinary heights.

Novice designers may think that they are alone in suffering from designer's block, but even those with glowing resumes and hefty portfolios can find themselves grappling for the right idea that will pull a project together. How often do *you* find yourself with a vacant canvas? While this may be frustrating, the more important question to ask is where do your ideas come from? The answer is what separates beginning designers from the experienced.

The designers and illustrators showcased in these pages kindly provided insights to their favorite haunts for inspiration and shared their favorite books, Web sites, and other obscure sources they turn to for that "aha!" moment. Their sources of inspiration are as varied as their design styles, running the gamut from a favorite professor of design to one of the old Masters to odds and ends picked up in an old book shop.

The Art of Design seeks to be both a handbook—a resource for locating and pinpointing myriad sources of inspiration—and a source of inspiration itself.

Inspiration can be as elusive as quicksilver: there one moment and gone the next. But once captured, it alone can make a project take flight to the point that it designs itself.

DES

[section]

1

inspired by

[*fine art*]

Most often, designers turn to their roots when seeking inspiration. For many designers, those roots are in the fine arts, so that is where they turn when searching for ideas. It is like seeking out a favorite overstuffed chair to settle in with a good book, or sitting down to eat a favorite meal; there is a measure of comfort in what we know that relaxes the mind and allows it to travel to new horizons.

Designers can be inspired by anything or anyone, but there are some names that come up more frequently than others: Monet, da Vinci, Matisse, Picasso, Warhol. Through the styles, approaches and color palettes of these artists and others, designers find their inspirations.

Everyone sees something different. Inspiration is in the eye of the beholder.

what inspires you?

 seymour CHWAST

>>>

His work can be seen every other Saturday on the op-ed page in *The New York Times*. You can catch his illustrations occasionally in *The New Yorker*. He is the recipient of the coveted Saint Gaudens Medal from The Cooper Union and was the American Institute of Graphic Arts 1985 Gold Medalist. In 1984, he was inducted into the Art Director's Hall of Fame, and received an honorary Doctor of Fine Arts degree from New York's Parsons School of Design in 1992. With such an impressive resume, one wouldn't think that Seymour Chwast (who in 1954 cofounded The Pushpin Studio, which later became The Pushpin Group) is ever at a loss when he looks at a blank canvas.

So where does Seymour Chwast seek inspiration?

"I've been inspired by design styles of the past . . . Victorian, art nouveau, art deco, modernism: all of those things have gotten into my work," says Chwast. When he was going to school he liked Ben Shahn (Lithuanian-American social-realist

painter, 1898–1969) and Francisco de Goya (Spanish rococo–romantic painter and print-maker, 1746–1828). "They tended to be very straightforward, very graphic, and different from the mass illustration that was done at the time."

"I prefer to do something that is accessible but direct. I got involved in doing woodcuts very early. I use that for doing illustrations. I produced a book in woodcuts shortly after I graduated: *The Book of Battles*, which was privately printed."

Chwast specializes in graphic design, illustration, and a combination of both. "I like to solve graphic problems, whether it is for design or an illustration. I love doing posters. Posters are interesting because you have the words and the image that you have to deal with, and you end up with something that can be very powerful. While [posters] are temporary in nature, they are meant to give an impression and a message. When they are good they can last a long time."

Chwast's unique work, which is world-

renowned, has been known to provide inspiration to others as well. "I've been imitated. Some of it is flattering. Occasionally things have been so close to my work, it got a little scary. But other than that, we all take from everybody and everything. It is really part of mainstream culture, so it is OK.

"I'm inspired by all different kinds of things: artists, printed material or things I see in the street—whatever. That is appropriating from anything that goes on. We all do that, but it is all within the visual language so that somebody should take from me what is appropriate for what they are working on.

"Last week, I saw a book jacket at a show at AIGA that was a negative. The next day I put a drawing that I did partially in negative, which was a good solution. It was in last Friday's *New York Times* on the op-ed page. . . . Sometimes methods, not only style, can inspire."

To learn more about Seymour Chwast's work, visit www.pushpininc.com.

STUDIO
The Pushpin Group Inc.

ART DIRECTOR
Judy Gailan

ILLUSTRATOR
Seymour Chwast

CLIENT
The Atlantic Monthly

COLORS
4-color process

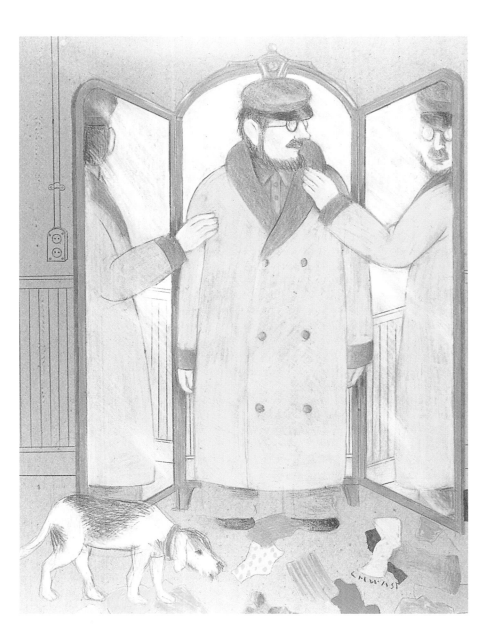

THE OVERCOAT

ILLUSTRATOR SEYMOUR CHWAST WAS inspired by the works of Belgian surrealist painter René Magritte when creating this illustration for a story in *The Atlantic Monthly*. Magritte is noted for works that contain an extraordinary juxtaposition of ordinary objects or an unusual context that gives new meaning to familiar things.

[SOURCE OF INSPIRATION]

■ **René François Ghislain Magritte (1898–1967). Magritte himself was inspired by other artists; in fact, he created surrealist versions of famous paintings, such as Madame Récamier de David (1949, private collection), in which an elaborate coffin is substituted for the reclining woman in the famous portrait by Jacques-Louis David.**

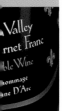

>

L'ECOSSE WINE LABEL

A FINE ART STOCK ILLUSTRATION OF Joan of Arc was the perfect choice for this Cabernet Franc because the wine comes from the same area in France that she was from. The stunning visage of the young Joan of Arc creates an ethereal, old-world feeling that is unique among wines—making this one stand out from other vintages. The art mirrors the tradition, heritage and richness of the wine perfectly. The run consisted of only five thousand labels and each was hand-applied.

[SOURCE OF INSPIRATION]

■ **Joan of Arc and other regional, old-world icons**

STUDIO
MOD/Michael Osborne Design

ART DIRECTOR
Michael Osborne

DESIGNER
Paul Kagiwada

CLIENT
L'Ecosse

SOFTWARE
Adobe Illustrator

PAPER
Label stock

COLORS
4-color process

PRINT RUN
5000

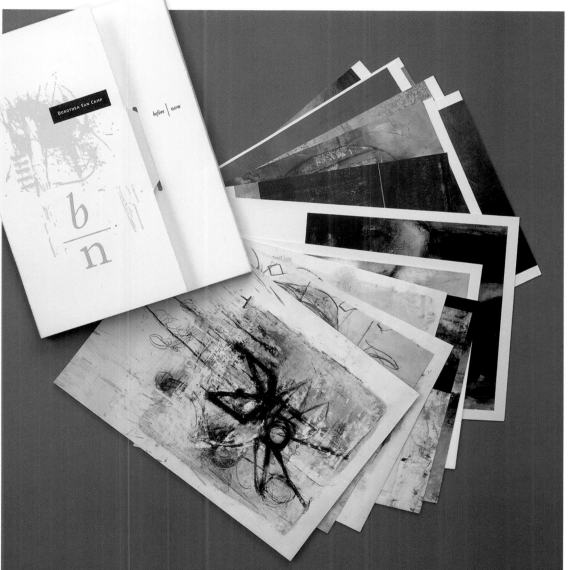

STUDIO
Stoltze Design

ART DIRECTOR/DESIGNER
Clifford Stoltze

ARTIST
Dorothea Van Camp

CLIENT
Dorothea Van Camp

SOFTWARE
Quark Xpress, Adobe Photoshop

PAPER
postcards: Sappi Strobe;
portfolio: French Construction

COLORS
postcards: 4-color process,
portfolio: 2 PMS colors and black

PRINT RUN
500

<

DOROTHEA VAN CAMP PORTFOLIO

"DOROTHEA VAN CAMP IS A FINE ARTIST whose work also hangs in my own home," says Clifford Stolze. "She asked me to design an updatable portfolio which would include fifteen postcards of her current paintings." Inspired by Van Camp's work, Stolze set to work and created the portfolio artwork. He based the cover artwork on a detail in one of her works and coupled the line art graphic with the series title. Letterpress printing was chosen because it complemented the "tactile, painterly, delicate, luminescent quality of Dorothea's work," adds Stolze.

[SOURCE OF INSPIRATION]

■ **Dorothea Van Camp, American artist**
(www.unit35.com)

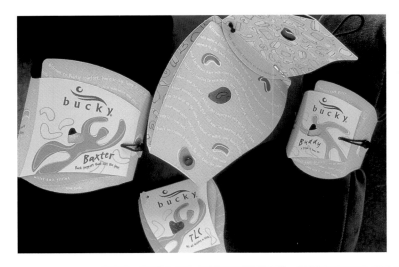

>
BUCKY LOGO AND PACKAGING

BUCKY, A DESIGNER AND MANUFACTURER of comfort-based products, asked Hornall Anderson Design to redesign its logo and packaging. The result is a fluid, human-like figure that is reminiscent of the style of the famous French painter Matisse. "The fluidity of the style played a major part in the graphics chosen, as it incorporated the thought of the product moving with you—or molding to you—as a result of its natural filling and product architecture," says Jack Anderson, art director.

[SOURCE OF INSPIRATION]

Henri Matisse
- **www.matisse.com.au**
- **www.ocaiw.com/1matisse.htm**
- *Matisse Portraits* **by John Klein**
- *Matisse on Art (Documents of Twentieth-Century Art)* **by Henri Matisse, Jack Flam (Editor)**
- *Henri Matisse (Getting to Know the World's Greatest Artists)* **by Mike Venezia**

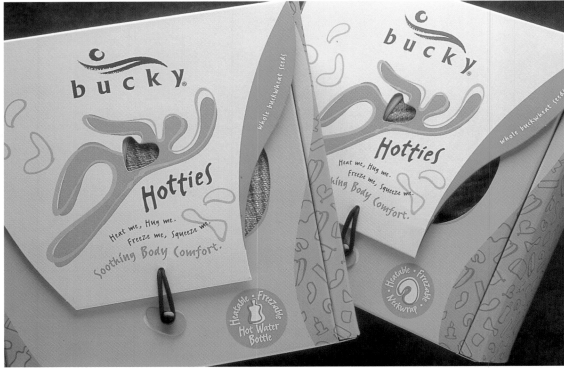

STUDIO
Hornall Anderson Design Works

ART DIRECTOR
Jack Anderson

DESIGNERS
Jack Anderson, Mary Hermes, Gretchen Cook, Henry Yiu, Elmer de la Cruz

ILLUSTRATOR
Laurie Rosenwald

CLIENT
Bucky

SOFTWARE
FreeHand

COLORS
4 PMS colors

> "We were exposed to Mary's images through a fine art rep. There have been many projects where we source images that have never been reproduced for commercial use."
>
> — GLENDA RISSMAN

STUDIO
Q30 Design Inc.

ART DIRECTOR
Glenda Rissman

DESIGNER
Vaspal Riyait

PHOTOGRAPHER
Mary Pocock

SOFTWARE
Adobe Illustrator, QuarkXPress

PAPER
Mohawk Navajo

COLORS
4-color process plus 2 match colors

PRINT RUN
500–2000

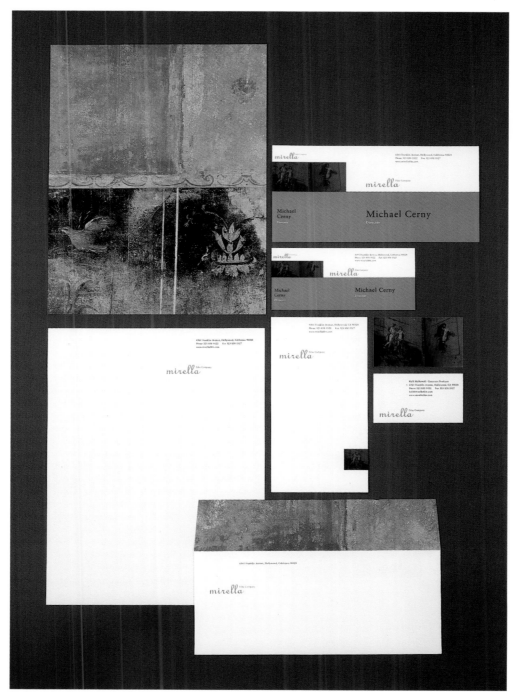

<

MIRELLA FILM CO. IDENTITY AND STATIONERY

MIRELLA, A FILM COMPANY SPECIALIZING in television commercials, tapped Q30 Design Inc. for a new identity. The company's name, Mirella, is a woman's name in Italian and the company strives to covey truth and beauty in its productions. With this in mind, art director Glenda Rissman immediately thought of Mary Pocock, whose work includes a series of photographs of beautiful frescoes in Pompeii.

The images are complemented by the choice of two typefaces—Dorchester Script and Sabon—and the overall identity is rendered in a warm burnt sienna.

"Her framing of these images, the color, and the detail of the decay of time make them exquisite fine art images," says Rissman. "We felt her images represented the corporate philosophy of Mirella."

[SOURCES OF INSPIRATION]

■ **Frescoes in Pompeii**
■ **Mary Pocock's work (www.keylight.org)**

>

STAMPED OUT MONA LISA

THIS MOSAIC OF THE MONA LISA WAS Palazzolo Design Studio's submission to a national contest hosted by the Mead Paper Company. Contestants were given a 26" x 40" (66 cm x 102 cm) sheet of white Mead paper embossed with the firm's logo, and the rest was up to the designer. "We chose to create a caricature of a universally recognizable piece of art, but we 'funned' it up by creating the lovely lady from stamps that we used as part of our own self-promotional package," says Gregg Palazzolo.

The result is an expert demonstration of how graphic design can be used to salute, pay homage to—or in this case, spoof—fine art. While the creation did require a lot of man-hours, it was inexpensive to produce: Palazzolo used an 89-cent Sharpie marker, white illustration board that cost $2.50 U.S., and stamps that were produced five years ago.

This wacky take on the da Vinci masterpiece earned Palazzolo Design Studio a first-place finish, along with a trip for four to help unveil an art show in New York City.

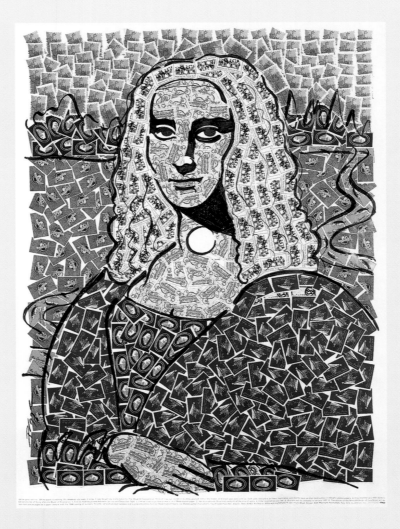

[SOURCES OF INSPIRATION]

■ **A.M. Cassandre, French commercial artist (1901–1981)**
■ **Alexander Calder, American artist (1896–1976)**
■ **Leonardo da Vinci, Italian artist (1452–1519)**

"I think I was up until almost midnight licking stamps! Viva la Mona Lisa!"
— GREGG PALAZZOLO.

STUDIO
Palazzolo Design Studio

ART DIRECTOR/DESIGNER/ILLUSTRATOR
Gregg Palazzolo

CLIENT/SERVICE
Mead Paper Company national competition

PAPER
Mead Signature Matte

SIZE
26" x 40" (66 cm x 102 cm)

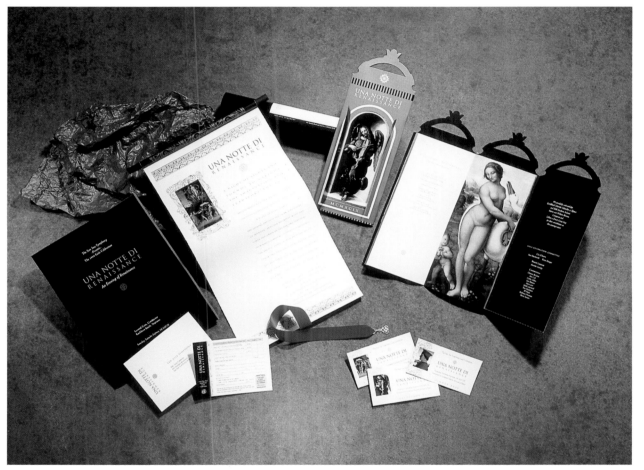

ART DIRECTOR
Boyd Tveit

COPYWRITER
Scott Murray

DESIGNER
Tracy Spencer

CLIENT
San Jose Symphony

SOFTWARE
Quark Xpress, Adobe Illustrator,
Adobe Photoshop

COLORS
4-color process plus one metallic
with spot varnish and die cut

SIZE
scroll invitation 9 3/8" x 19";
reply card 5 1/4" x 4"

PRINT RUN
1500

COST PER UNIT
$11.50 U.S.

TYPEFACES USED
Weiss, Trajan

<

SAN JOSE SYMPHONY GALA EVENT COLLATERAL

ACCORDING TO ART DIRECTOR BOYD Tveit, "This event, the Annual Gala, is the first of the Orchestra's season and is always produced as an exclusive and extravagant event attended by the captains of industry and Silicon Valley's social elite. The theme for this year's show was 'Una Notte Di Renaissance'.

"The Renaissance was a great period of creative expression in the arts. We used that concept as the springboard to give visual connection to the theme. The event invitation was designed and assembled in scroll form to emulate nobility's format for formal proclamations of the period and was mailed in a gloss black mailing tube. The event program was designed as a three-sided stand up piece on each table setting whose die cut design emulated the friezes of the buildings of the period and contained beautiful art from the Italian masters as well as information about the featured artist, dinner menu, program, committee members and the symphony's key contributors."

>
THE LEARNING COMMUNITY INSTITUTES LOGO

"ALEXANDER CALDER'S PLAYFUL mobiles with their clean lines and changing views inspired this piece," says Barbara Brown, who drew the logo using just one line. Her goal was to capture the process of learning in a logo—listening, processing, and that "aha!" moment. She also took inspiration from cubism, capturing the four-dimensional elements of learning in a two-dimensional piece that "shifts, like a mobile, from one moment to the next."

[SOURCES OF INSPIRATION]

- Alexander Calder, American artist (1898–1976)
- Cubism

STUDIO
Barbara Brown Marketing
& Design

ART DIRECTOR/DESIGNER/
ILLUSTRATOR
Barbara Brown

CLIENT
The Learning Community
Institutes

SOFTWARE
Adobe Illustrator

COLORS
2 match colors

PRINT RUN
5000

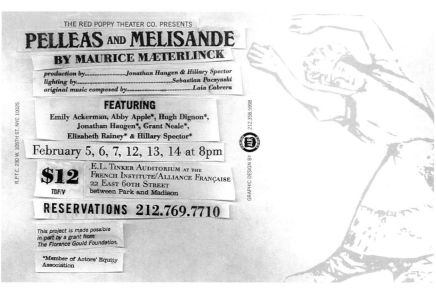

PÉLLEAS AND MÉLISANDE POSTCARD

STUDIO
ALR Design

**ART DIRECTOR/DESIGNER/
ILLUSTRATOR/PHOTOGRAPHER**
Noah Scalin

CLIENT
Red Poppy Theatre Company

SOFTWARE
QuarkXPress, Adobe Photoshop

COLORS
4-color process

SIZE
4" x 6" (10 cm x 15 cm)

PRINT RUN
1000

COST PER UNIT
$0.40 U.S.

THIS POSTCARD WAS COST-EFFECTIVELY produced for a unit cost of forty cents—despite the fact that it incorporates illustration, photography and an elaborate type treatment into the design. To keep costs to a minimum, the designer relied upon an assortment of standard typefaces and rather than pay for photography, the art was created small enough to fit onto a flatbed scanner and was scanned directly into Adobe Photoshop. Noah Scalin, who was wholly responsible for the design of this postcard, found inspiration in the work of Joseph Cornell.

"My discussion with the director of this play took place in a bookstore, so when I mentioned Joseph Cornell's work as a way to represent the dark and textured story that [the play] told, we were able to go directly to the art section and look at examples," says Scalin. "The director was unfamiliar with Cornell, but upon seeing a catalog of his work, was instantly enamored. She left with a copy of the book and I with my inspiration."

[S O U R C E O F I N S P I R A T I O N]

■ **Joseph Cornell, American artist
(1903–1972)**

>
SONATA WINE PACKAGING

TAKE A WINE WITH A MUSICAL NAME—
Sonata—and add Caio Fonesca, an
Italian-American painter whose abstract
paintings are based on musical themes,
and the match was too perfect to resist.
The result is two surprisingly simple wine
labels with an old world patina. Each label
is beautifully complemented by the
elegant yet lively calligraphy.

[SOURCES OF INSPIRATION]

- **Elements of music**
- **Caio Fonesca, Italian-American painter**

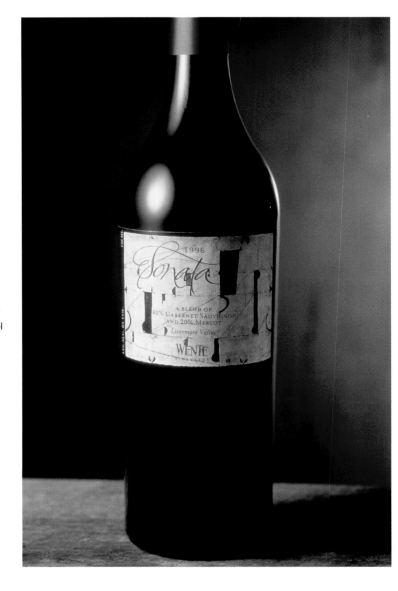

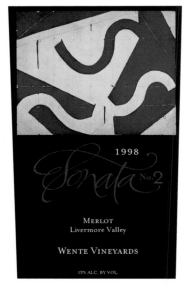

STUDIO
MOD/Michael Osborne Design

ART DIRECTOR
Michael Osborne

DESIGNER
Paul Kagiwada

ILLUSTRATOR
Caio Fonesca

CALLIGRAPHY
Georgia Deaver

CLIENT
Wente Vineyard

SOFTWARE
Adobe Illustrator

COLORS
4-color process and foil stamp

PRINT RUN
12,000

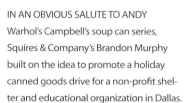

HOLIDAY CAN DRIVE BAG

STUDIO
Squires & Company

DESIGNER/ILLUSTRATOR
Brandon Murphy

CLIENT
Interfaith Housing Coalition

SOFTWARE
Adobe Illustrator

PAPER
Brown paper bag

COLORS
3 spot colors, silk screen

PRINT RUN
1000

COST PER UNIT
All work, including printing and
materials, was donated

IN AN OBVIOUS SALUTE TO ANDY
Warhol's Campbell's soup can series,
Squires & Company's Brandon Murphy
built on the idea to promote a holiday
canned goods drive for a non-profit shel-
ter and educational organization in Dallas.

"[The soup can] is such an icon that
we knew people would immediately see it
as a symbol for all canned goods. The trick
was to combine it with the 'roughness'
and 'need' of the less fortunate clients of
the Interfaith Housing Coalition of Dallas,"
says Murphy.

To effectively communicate the des-
perate situation of Dallas citizens in need
of food, Murphy digitally manipulated the
art to wrap the type and give it the appro-
priate texture by taping, scratching, and
roughing up the typefaces, which includ-
ed Futura, Helvetica, and Opti Sport Script.

The design team remained true to
Warhol's work by silkscreening the
design—which was also the logical choice
for printing on the brown paper bags.

[SOURCES OF INSPIRATION]

- **Andy Warhol, American pop artist
 (1928–1987)**
- **Silkscreen techniques**

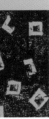

SAM'S BAR

"I'VE BEEN INFLUENCED BY WOODCUT artists José Guadalupe Posada and Antonio Frasconi," says Seymour Chwast, noting that this spread included in his book *Sam's Bar* was executed entirely with woodcuts.

[SOURCES OF INSPIRATION]

▪ **José Guadalupe Posada, Mexican engraver (1852–1913)**

▪ **Antonio Frasconi, Argentinean artist (born 1919)**

STUDIO
The Pushpin Group Inc.

ILLUSTRATOR
Seymour Chwast

WRITER
Donald Barthelme

PUBLISHER
Doubleday

COLORS
2 colors

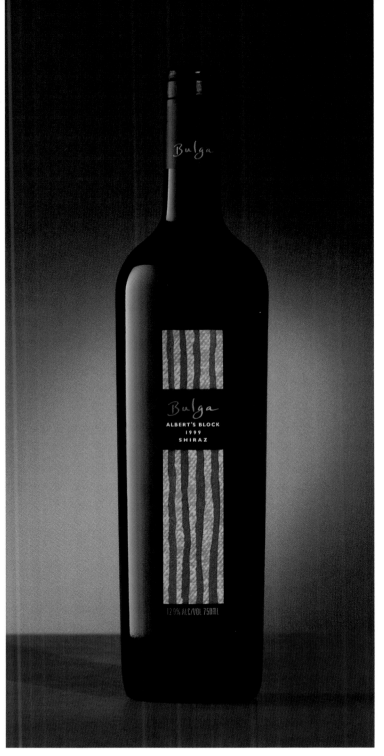

STUDIO
CPd—Chris Perks Design

ART DIRECTOR/DESIGNER/
ILLUSTRATOR
Chris Perks

PRODUCT PHOTOGRAPHER
Les Horvat

CLIENT
Bulga Wines

SOFTWARE
Adobe Illustrator, Adobe
Photoshop

COLORS
4-color process and 1 match
color—gold

PRINT RUN
1000

BULGA WINE LABEL AND IDENTITY

BULGA WINES NEEDED A NEW CORPORATE
identity that reflected its history, integrity,
and honesty. To attain these goals, CPd
turned to the work of Emily Kame Kng-
warreye, an Australian Aboriginal artist
whose works are recognized worldwide
for their innovation and daring.

"The brand identity is a broad-stroke
rendition of a watering hole…while the
label design represents an aerial view of
the Bulga vineyards and draws from Kame
Kngwarreye's artistic depiction of a similar
setting," says Chris Perks. "Bright colors
depict the region's red earth, which con-
trasts boldly against the green ripening
of the vines."

[SOURCES OF INSPIRATION]

■ *Fluent*, an exhibition that toured
 Australia and Venice in 1977, displaying
 works of three Australian Aboriginal
 artists, and the catalog created for this
 exhibition.
■ Emily Kame Kngwarreye, Australian
 Aboriginal artist (1910–1996)

>
MASSACHUSETTS COLLEGE OF ART CATALOG

THE MASSACHUSETTS COLLEGE OF ART offers programs spanning across fine arts, media studies, and design. "We explored the inter-connectivity of these varied visual disciplines, finding common ideas across them," says Clifford Stolze. "All art forms—be they two-dimensional, three-dimensional, or virtual—can be reduced to or comprised of the basic building blocks of geometric and organic form. The geometric forms found within the book and the cube-like form of the book itself speak to this foundation of studies."

When creating this viewbook, Stolze found inspiration in the work of the art students and the world in which they live, while the covers of the books are reminiscent of a Paul Klee painting, using transparency to connect the forms found within the books.

[SOURCES OF INSPIRATION]

- **Paul Klee, Swiss artist (1879–1940)**
- **Cubism and elements of geometry**

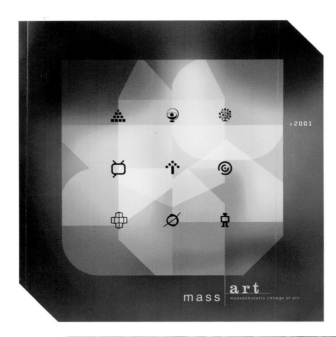

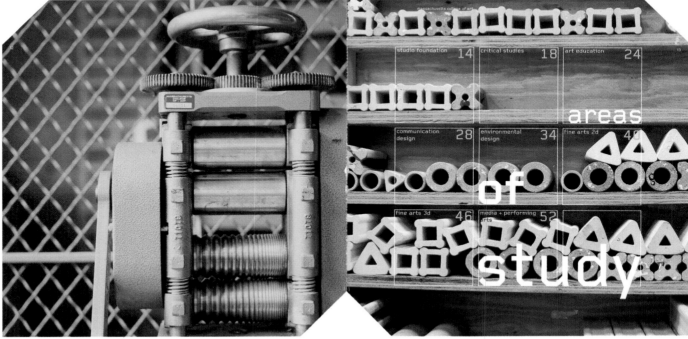

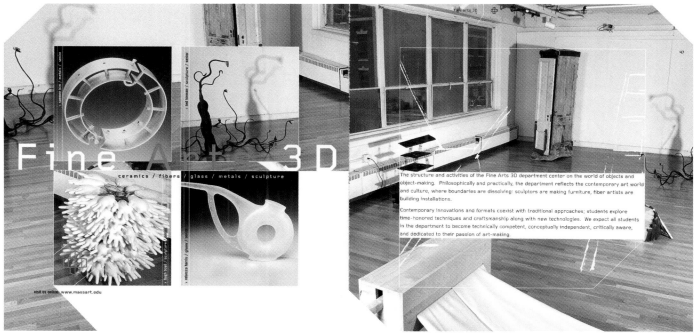

STUDIO
Stoltze Design

ART DIRECTOR
Clifford Stoltze

DESIGNERS
Clifford Stoltze, Tammy Dotson,
Cindy Patten

CLIENT
Massachusetts College of Art

SOFTWARE
QuarkXpress, Adobe Photoshop,
Adobe Illustrator

PAPER
Sappi Opus

COLORS
4-color process plus
1 match color

PAGES
72

PRINT RUN
30,000

> DAN MAGREE PHOTOGRAPHY VISUAL IDENTITY

PHOTOGRAPHER DAN MAGREE RETAINED designers at CPd to create a brand signature for his work that expressed his photographic diversity, which ranges from studio subjects to the environment. To that end, they turned to the Bauhaus and Arts and Crafts movements for inspiration, primarily because of the pure geometric forms characteristic of these styles. Specifically, they followed the works of László Moholy-Nagy's series of photograms symbolizing architecture, food, and still life that are merged to create a technical layering of aesthetic meaning.

"Working with the qualities of light, shadow, and detail, the photograms have been assembled into a visually intriguing composition suggestive of Moholy-Nagy's constructivist style," says Alan Morrison, designer on the project.

[SOURCES OF INSPIRATION]

- **The Conran Directory of Design by Stephen Bayley**
- **László Moholy-Nagy, Hungarian painter and photographer, (1895–1946)**

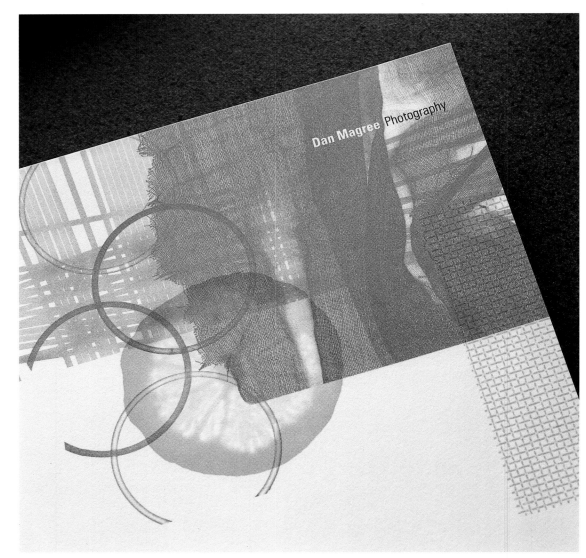

STUDIO
CPd—Chris Perks Design

ART DIRECTOR
Chris Perks

DESIGNER
Alan Morrison

CLIENT
Dan Magree Photography

SOFTWARE
Adobe Illustrator, Adobe Photoshop

PAPER
Saxton White Smooth 140 gsm

COLORS
3 match colors: PMS 549U, PMS 611U, and black

PRINT RUN
1500

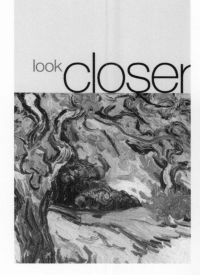

look closer

STUDIO
Henderson Bromstead Art

ART DIRECTOR
Hayes Henderson

DESIGNER
Michelle White

ILLUSTRATOR
Vincent Van Gogh

CLIENT
Hanes

SOFTWARE
Adobe Illustrator

COLORS
5 over 5

PAGES
12

SIZE
6" x 9" (15 cm x 23 cm)

PRINT RUN
20,000

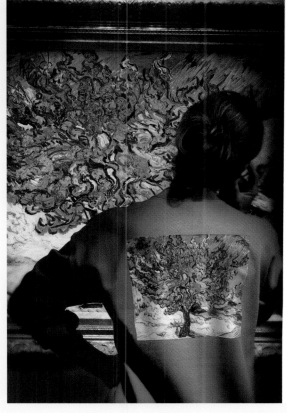

great
art
begins with a great
canvas

<
LOOK CLOSER BROCHURE

SURPRISINGLY, THIS UPSCALE BROCHURE is not for a new gallery showing, but for PrintPro, a line of Hanes printable fleece. The headline, "Look Closer," draws the reader into the brochure where the minimal copy says that "great art begins with a great canvas." As it turns out, the artwork that we're looking at is not a painting, but a close-up of Vincent Van Gogh's art as recreated on a sweatshirt. "Van Gogh's art seemed to best express the qualities of imagery that is impactful from a distance and even more intriguing up close," explains Hayes Henderson, art director.

[SOURCE OF INSPIRATION]

■ **Vincent Van Gogh, Dutch painter
(1853–1890)**

>

VISIONS OF THE WEST COLLECTION

THE VISIONS OF THE WEST COLLECTION, previously called the *Torch Collection*, showcases J.P. Bryan's private collection of American West paintings and artifacts collected throughout his thirty-year career in the energy industry. The brochure was created to show a small cross-section of Bryan's collection. Because of the magnificence of the art and artifacts, designers at Squires & Company decided to let the pieces themselves determine the layout, colors and feel of the brochure.

Designer Brandon Murphy allowed the artwork itself to be the focus, keeping the backgrounds and type subtle and complementary, and using such faces as Bernhard, Black Oak, and Woodtype Ornaments to dress up the pages. Costs were minimized by keeping the brochure small—10" x 7" (25 cm x 18 cm)—and by using a self-cover, which was given added strength by including a fold-out panel.

The artwork included in the book—all original works—are great sources of inspiration for creating and maintaining the feel of America's Old West.

[SOURCES OF INSPIRATION]

- *Mexican Girl*, William Elliot, oil on board, 1934
- *Cowboys and Indians Series: Geronimo*, Andy Warhol, serigraph on paper, 1986
- *Horse Race*, Carl Dixon, wood, paint, and glitter, 1997
- *Hell Skull*, Ronald Cooper, horse's skull, enamel paint and clothespins, c. 1990
- *The Rescue of Lt. Bullis*, Fronzel L. "Doc" Spellmon, oil on canvas, c. 1981
- *John Wayne*, Ike Edward Morgan, pastel and ballpoint pen, c. 1985
- *Ex-Voto*, oil on canvas mounted on paper, 1883
- *Pulling Leather*, William Robinson Leigh, oil on canvas, 1952
- *Big Bend*, Everett Spruce, oil on board, 1945

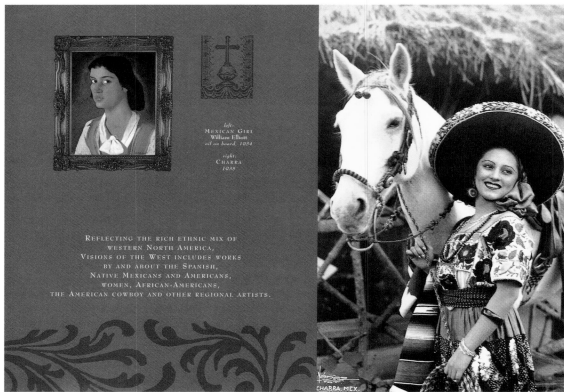

left:
MEXICAN GIRL
William Elliott
oil on board, 1934

right:
CHARRA
1935

REFLECTING THE RICH ETHNIC MIX OF
WESTERN NORTH AMERICA,
VISIONS OF THE WEST INCLUDES WORKS
BY AND ABOUT THE SPANISH,
NATIVE MEXICANS AND AMERICANS,
WOMEN, AFRICAN-AMERICANS,
THE AMERICAN COWBOY AND OTHER REGIONAL ARTISTS.

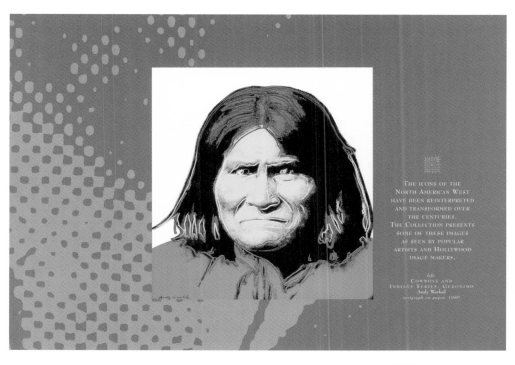

THE ICONS OF THE
NORTH AMERICAN WEST
HAVE BEEN REINTERPRETED
AND TRANSFORMED OVER
THE CENTURIES.
THE COLLECTION PRESENTS
SOME OF THESE IMAGES
AS SEEN BY POPULAR
ARTISTS AND HOLLYWOOD
IMAGE MAKERS.

left:
COWBOYS AND
INDIANS SERIES, GERONIMO
Andy Warhol
serigraph on paper, 1986

"The overriding theme of textures is illustrated through the close-up patterns and details extracted from the artwork and items. We wanted to give the viewer a more tactile experience of the collection."

— BRANDON MURPHY

STUDIO
Squires & Company

DESIGNER
Brandon Murphy

ILLUSTRATORS
Various

CLIENT
Torch Energy Advisors

SOFTWARE
Adobe Photoshop, QuarkXPress

PAPER
Monadnock Dulcet

COLORS
4-color process, spot, and
satin varnish

PAGES
14-page self-cover with fold-out

SIZE
10" x 7" (25 cm x 18 cm)

PRINT RUN
3500

COST PER UNIT
$3.00 U.S.

> TALK RADIO IS MURDER POSTER

THE IMAGE OF AN OLD-TIME RADIO microphone is given an eerie twist when you note the cut electrical cord and blood dripping from the mouthpiece. Yet, the primary color palette reassures us that this is not a gloomy mystery, but one that doesn't take itself too seriously.

"The image of a bleeding microphone with a disconnected cord was produced for a murder-mystery dinner benefit—a lighthearted way of both socializing and actively participating in the investigation of a slain radio commentator," says Gregg Palazzolo. "We purposely used thick border lines and primary colors to convey the feel of a kid's coloring book. We wanted, after all, whimsy—not the macabre.

"It was a playful event, and we felt compelled to mirror that feeling."

[SOURCES OF INSPIRATION]

- **Massimo Vignelli, Italian-American designer (born 1931)**
- **Pablo Picasso, Spanish painter and sculptor (1888–1973)**

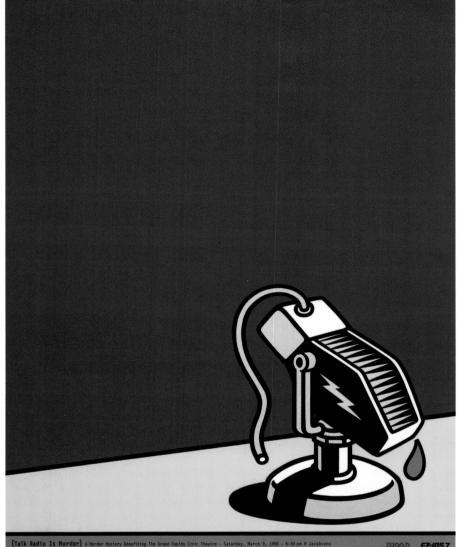

"The image is purposely absent of any type, leaving the illustration alone to serve as the clue-giver,"

— GREGG PALAZZOLO

STUDIO
Palazzolo Design Studio

ART DIRECTOR/DESIGNER/ ILLUSTRATOR
Gregg Palazzolo

CLIENT
Civic Theater of Grand Rapids

SOFTWARE
Adobe Illustrator

PAPER
Strathmore Renewal White Text, 80 lb.

COLORS
4 match colors

SIZE
24" x 38" (61 cm x 97 cm)

PRINT RUN
2500

PROVIDENCE HOMES IDENTITY

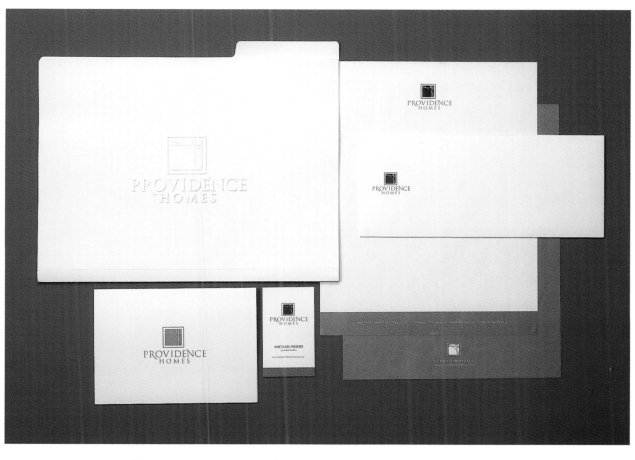

STUDIO
2cdesign

ART DIRECTORS
Christine Guiang, Chris Esworthy

DESIGNER
Ann Livingston

CLIENT
Providence Homes

PAPER STOCK
Navajo Brilliant Smooth
cover and text weights

COLORS
2 over 1

PRINT RUN
1500

COST PER UNIT
letterhead: $0.34 U.S.
envelopes: $0.52 U.S.
business cards: $0.75 U.S.

[SOURCES OF INSPIRATION]

- **Museum of Modern Art, New York**
- *The History & The Collection* **by Sam Hunter**
- *Wallpaper* **magazine, Time, Inc.**
- **Frank Lloyd Wright, American architect (1869–1959)**

THE ARCHITECTURAL STYLE OF FRANK Lloyd Wright provided the inspiration for this letterhead system for Providence Homes, a small company that oversees the construction of custom-made, multi-million-dollar estates. "While researching for this identity piece, the architecture of Frank Lloyd Wright became a huge inspiration," says Ann Livingston, designer.

"Our client was set on having a window for his mark: therefore it was our job to create a logo that reflected a window, yet still spoke to the customized homes being built. Frank Lloyd Wright's *Window Triptych* from the Avery Coonley Playhouse provided great insight to how windows could be tailored without losing the basic elements of a window."

The system has a spare, minimalist quality, so it is no surprise that great care was taken to ensure that every nuance was perfect—including the typography. "I wanted to make sure that the type in the logo reflected the elegance of the homes that are being produced by Providence Homes. Therefore, the typeface Trajan was altered. It makes the mark a bit more sophisticated and customized, which speaks to both the quality of the homes and the client," explains Livingston.

>
THE MOORS CD

THE INSERT IN THE MOORS CD FEATURES full-page illustrations by Cynthia von Buhler for six of the songs. "This CD package was as much a promotional vehicle for the illustrator as it was a container for some incredible Celtic/gothic/pagan music," says Clifford Stoltze.

"I focus almost exclusively on three-dimensional portraits, with canvas holes often cut into the head or heart, laying bare what hides underneath," says Cynthia von Buhler, illustrator. "I pursue the juxtaposition of painted renaissance portraiture and the surrealism of the 'real' object within the painting, using portraiture to show the inner life through the symbolism of a simple unrelated object. Objects such as butterflies, broken clocks, or frog skeletons dangle provocatively in shadowy recesses. Live and taxidermied birds are often seated in cages within the pieces, describing trapped emotions. Layering gouache paint on large canvases incorporating wood, plaster, text, and 3-D objects, I give my perception of the human condition."

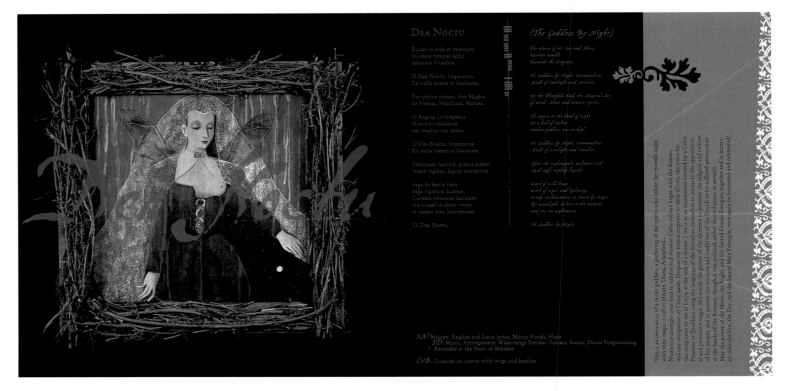

"In 1997 I lodged at Scotland's Roslyn Castle near Edinburgh. After that visit, I researched the great Celtic and Pagan goddesses, which gave rise to a series of female goddess portraits," says Cynthia von Buhler. "The subject matter opened up the idea of frames made of organic materials such as bark, shells, and twigs. Bat wings, shells, and moths are glued to the paintings and incorporated into the portraits."

— CYNTHIA VON BUHLER

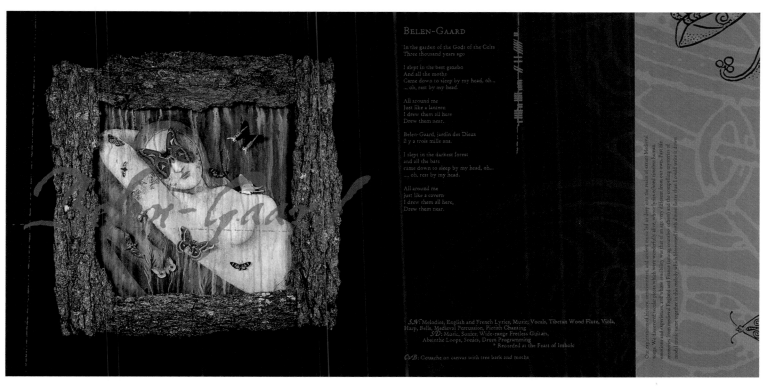

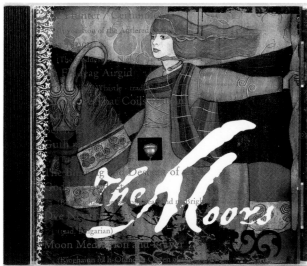

"I am a storyteller who enjoys revealing the hidden stories. We all have our outward stories of who we are, how we make our living, what we wear, how we want to be perceived—but what truly interests me are the stories we normally choose not to tell."

— CYNTHIA VON BUHLER

STUDIO
Stoltze Design

ART DIRECTOR
Clifford Stoltze

DESIGNERS
Clifford Stoltze, Brian Azer

ILLUSTRATOR
Cynthia von Buhler

CLIENT
Castle von Buhler Records

SOFTWARE
Quark XPress, Adobe Photoshop

PAPER
Luna Gloss Text

COLORS
6 over 6

PAGES
20

SIZE
4³/₄" x 4³/₄" (12 cm x 12 cm)

PRINT RUN
3050

COST PER UNIT
$1.65 U.S.

>
SUFFER OR ORGANIZE POSTERS

THESE POSTERS WERE CREATED TO WARN the public that they were under threat from legislation proposed by the government of Ontario, Canada. In the same way that Andy Warhol captured the portraits of Elizabeth Taylor, Elvis Presley, and perhaps most notably, Marilyn Monroe, James Peters portrayed social diversity through a variety of different faces."I took Warhol's technique and married it to the way comic book artists color and shade faces," says Peters.

"The Warhol comic book technique of describing a face in flat, bold colors worked as a nice complement to the direct challenge proposed by the messages of the posters. The point was to not be subtle but to be blunt and urgent. This was also the reason for the rich, hot colors used in the backgrounds and in the type."

[SOURCES OF INSPIRATION]

- **Andy Warhol, American pop artist (1928–1987)**
- **Comic books**

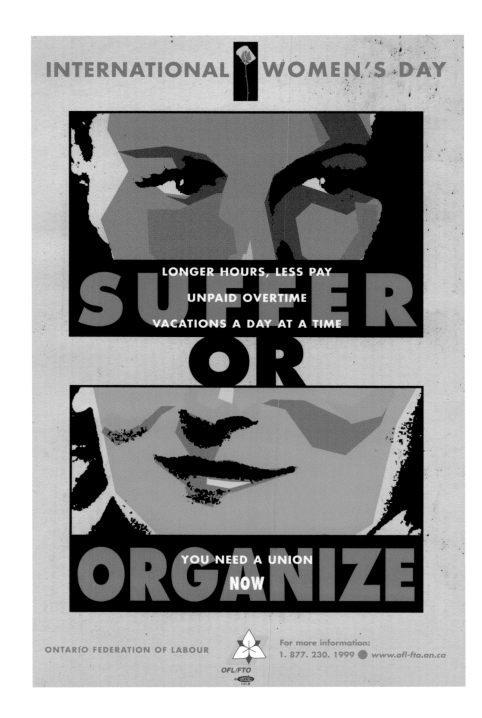

STUDIO
Terrapin Graphics

ART DIRECTOR/ILLUSTRATOR
James Peters

SOFTWARE
Adobe Photoshop, Adobe Illustrator, QuarkXpress

PAPER
Cornwall CIS Cover Stock 8 pt.

COLORS
4-color process

SIZE
11" x 17" (28 cm x 43 cm)

PRINT RUN
10,000

COST PER UNIT
$0.57 U.S.

"I don't only consult [art] books when I'm in search of an idea for a particular job, but also look at them for pleasure. I love reading about the technical side of art: why an artist selected a particular kind of canvas or paper for a week, the kind of paints he or she used, how they used them, what particular tricks they employed, et cetera."

—JAMES PETERS

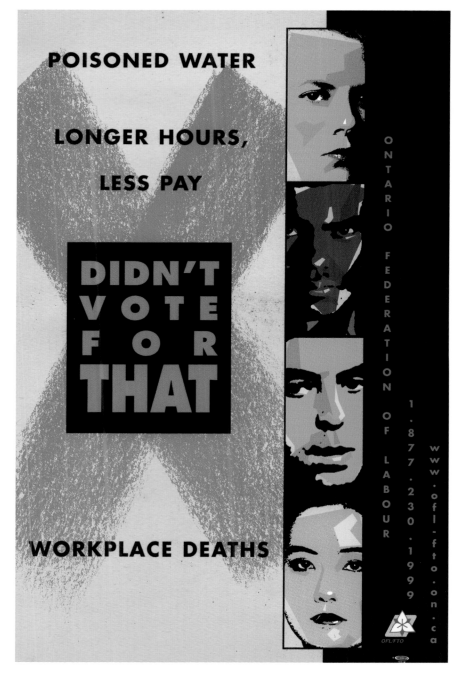

<

DIDN'T VOTE FOR THAT

STUDIO
Terrapin Graphics

ART DIRECTOR/ILLUSTRATOR
James Peters

SOFTWARE
Adobe Photoshop, Adobe Illustrator, QuarkXpress

PAPER
Cornwall CIS Cover Stock 8 pt.

COLORS
4-color process

SIZE
11" x 17" (28 cm x 43 cm)

PRINT RUN
original print run of 5000 with a reprint of 10,000

COST PER UNIT
$0.52 U.S.

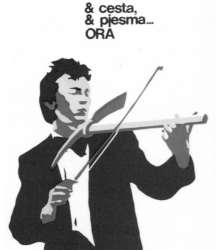

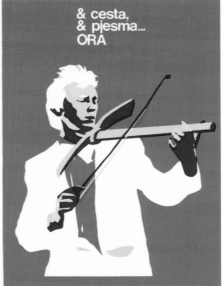

>

& CESTA, & PJESMA…

THE YOUTH UNION IS AN ORGANIZATION that promotes voluntary work. To keep pace with the changing perception of volunteering, the designers opted for a design that resembles Andy Warhol's works. Tomislav Mrcic, designer, explains their approach: "The idea was to blend mindwork and labor and make the image of volunteer work not as dull as perceived by the public, but show it in a way to arouse interest among the targeted audience and get publicity through the mass media."

The piece was created as a multipurpose folder to hold many types of communications—from art and photo exhibit announcements to invitations for concerts, discussions on ecology, and more. "As it was designed for a relatively small, exclusive audience of journalists and lobbyists, inserts or direct silkscreen prints using old Letraset typefaces were used for announcements of particular events," says Mrcic.

[SOURCE OF INSPIRATION]

■ **Andy Warhol, American pop artist (1928–1987)**

"We used a pop-artistic approach to popularize volunteer work, which is, by its definition, unpopular. We do live in a materialistic world, don't we?"

— TOMISLAV MRCIC

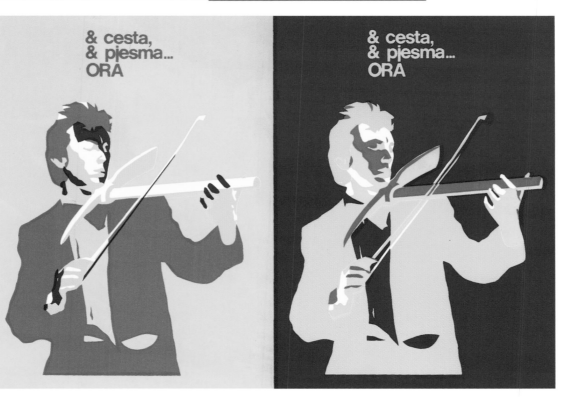

STUDIO
Likovni Studio

ART DIRECTOR
Mladen Tabak

DESIGNER
Tomislav Mrcic

ILLUSTRATOR
Danko Jaksic

CLIENT
Youth Union

PAPER
Chromolux 300 g/m2

COLORS
4 match colors

PRINT RUN
500

>
ROTHBURY ESTATE WINE LABEL RANGE

CPD'S WORK WITH BERINGER BLASS'S Rothbury Estate range of wines is reminiscent of the avant-garde woodblock technique popularized in the 1920s and 1930s. CPd was commissioned to design a series of labels that could express the age-old hands-on approach to winemaking and its craftsmanship, while still appearing contemporary.

The design combines multiple typefaces—Snell Round Hand Script, Gils Sans, Bodini, and Univers—and places them on brightly colored panels that are laid upon a white label stock. Each label features an artistic typographic interpretation of the name of the wine region.

"CPd found inspiration in the work of Gröningen-based printer publisher Henrik Nicolaas Werkman. Werkman, who worked under the pseudonym Travailleur & Co., wrote and designed a magazine titled *The Next Call*," says Chris Perks.

Chris Perks maintains that Werkman had an enormous influence on both graphic designers of his own time as well as those of future generations. He also had much talent as a poet, which he

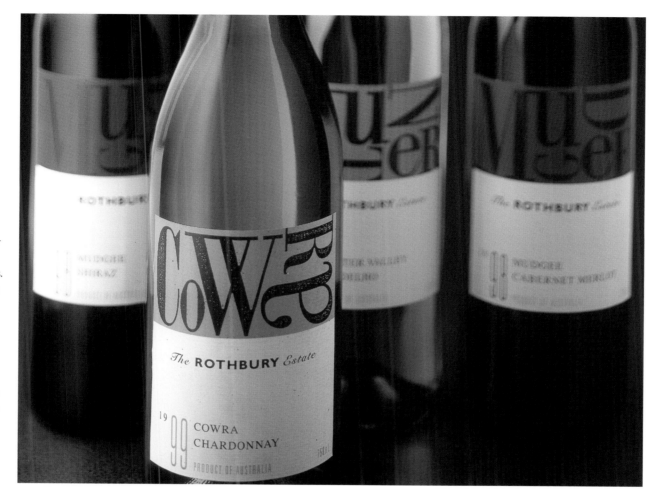

combined with his passion for the art of the time. Throughout issues of *The Next Call*, Werkman composed "visual poetry," in which numbers and lettering are constructed as pure visual compositions where form takes priority.

[SOURCE OF INSPIRATION]

■ **Henrik Nicolaas Werkman and issues of his magazine, *The Next Call***

STUDIO
CPd—Chris Perks Design

ART DIRECTOR/DESIGNER/TYPOGRAPHER
Chris Perks

PRODUCT PHOTOGRAPHER
Dan Magree

CLIENT
Beringer Blass

SOFTWARE
Adobe Illustrator, Adobe Photoshop

COLORS
3 match colors—black, gray PMS 429, and a special PMS for each varietal

PRINT RUN
20,000 per varietal

>

ANTIWALL CALENDAR

PUBLIKUM, A MAJOR PRINTER IN BEL-
grade, annually publishes an art calendar
with photography by contemporary Ser-
bian artists. In 1993, while brainstorming
ideas for the 2001 calendar, it was decided
to feature international artists. They
turned to Mirko Ilic Corp. for its design.

"The project is, in itself, more than an
ordinary art publishing project," says Ilic,
pointing out that the calendar comes out
of Serbia, which has suffered through
many wars and political crises in the last
decade. "It is a way of communication
among artists and a variety of people
since this calendar is donated to various
cultural institutions, artists, art organiza-
tions, and media in Serbia and in limited
number worldwide."

"Although the characters are hand-
written, they are faithful to the integrity
of a predesigned typeface. Handwritten
books have a history in Serbia, the country
in which this was printed. Many Greek
Orthodox books were produced in the
area as well as in Greece—part of the
'civilizing' of the Slavs," Ilic explains.

Glow-in-the-dark ink was used on
the package cover and inside pages of
the calendar.

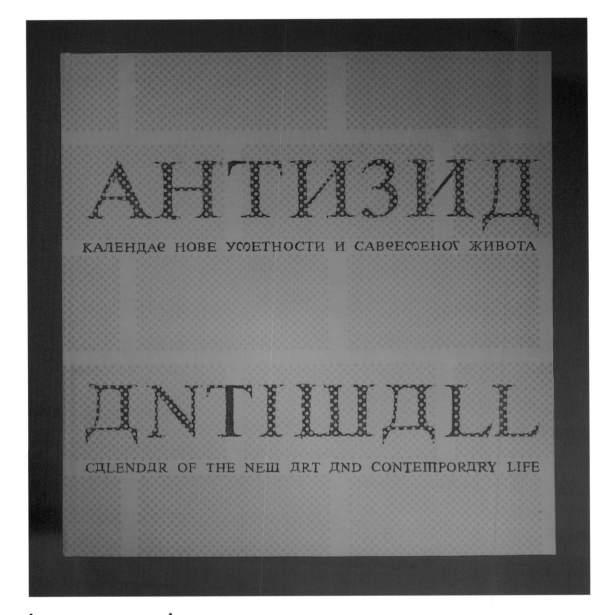

[SOURCES OF INSPIRATION]

- **Marcel Duchamp, French-American artist
 (1887–1968)**
- **Raoul Hausmann, Austrian dadist
 (1886–1971)**
- **Glenn Ligon, African-American painter
 (born 1960)**

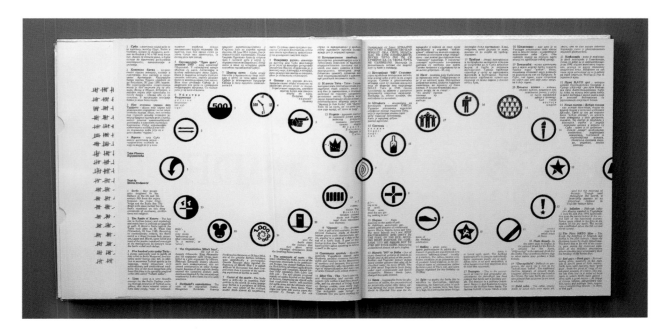

"The inspiration began with the Duchamp Dossier, Duchamp's 3-D work that collected printed ephemera into a box design. He used this approach in several other works," says Mirko Ilic. "We combined this idea with the handwritten, typographic collages of Raoul Hausmann, part of a long tradition extending into the contemporary work of Glenn Ligon."

Ilic designed his own typefaces: one called Englic, for all English text in the project, and another called Cifrilica for all Cyrillic text. He created Englic by combining digital cuts of Times from Latin and Cyrillic characters; he created Cifrilica by digitally reorganizing Cyrillic characters and numbers. After designing the faces, all text was printed out at 150 percent and traced by hand onto vellum, then scanned at a high resolution for the final product. "In the end, no two letters are alike," says Ilic.

*Inside the elaborately boxed
Publikum Art Calendar, Anti-
wall, are the works of twelve
renowned contemporary visual
artists: Wim Wenders, Vik
Muniz, Björk Gudmundsdóttir,
Dragan Zivadinov, Natacha
Merritt, Marina Abramovic,
Barbara Kruger, AES Group,
Tandanori Yokoo, Oliviero
Toscani, Christo and Jeanne-
Claude, and David Byrne.*

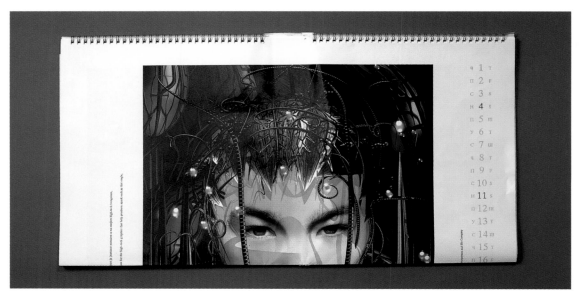

STUDIO
Mirko Ilic Corp.

ART DIRECTOR
Mirko Ilic

CREATIVE DIRECTORS
Nada Raiicic, Stanislav Shorpe
(FIA Art Group)

DESIGNERS
Mirko Ilic, Ringo Takahashi

ILLUSTRATOR
Slavimir Stojanovic

CLIENT
Publikum

SOFTWARE
QuarkXPress, Adobe Photoshop,
Adobe Illustrator

COLORS
2-colors and 4-color process and
spot glow-in-the-dark colors

SIZE
12" x 12.5" x 2"
(30 cm x 32 cm x 5 cm)

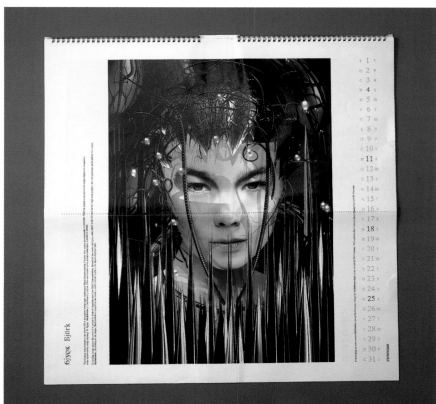

*The calendar's theme is over-
coming barriers and walls, not
only in art, but also in society
as a whole.*

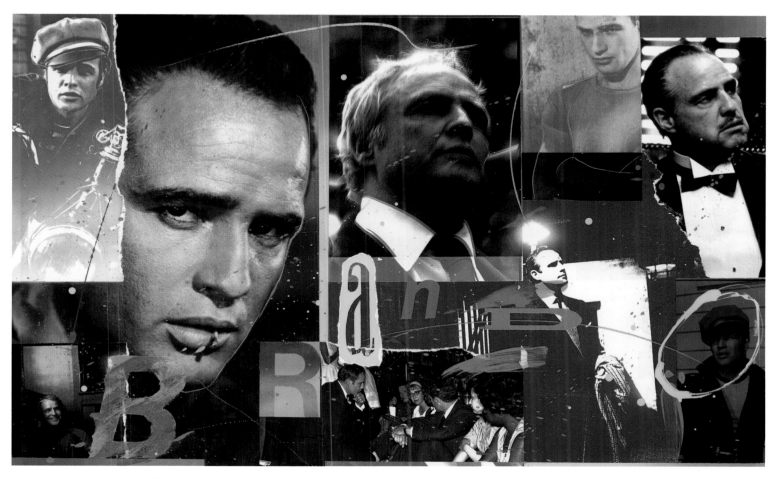

<
MARLON BRANDO

MIKE SALISBURY DREW UPON THE WORK of artist Wolf Vostell when creating this collage of Marlon Brando's film roles for the *Saturday Review*. Salisbury likes Vostell's unique collage style because it provides plenty of inspiration for using stock or otherwise mundane photos and giving them an artistic bent.

Salisbury created the Brando collage without any computer work; he simply cut, pasted, and then painted the lettering onto the final art.

[SOURCE OF INSPIRATION]

■ Wolf Vostell, German artist (1932–1998)

STUDIO
Mike Salisbury, LLC

ART DIRECTOR/DESIGNER
Mike Salisbury

ILLUSTRATOR
Terry Lamb

CLIENT
Saturday Review

COLORS
4-color process

SIZE
Double tabloid

SAN FRANCISCO 2012 OLYMPIC GAMES BID POSTER

PRIMO ANGELI WAS INSPIRED BY THE cubist movement when he created this poster for San Francisco's bid for the 2012 Olympic Games. This vivid poster was printed in four-color process, with two spot colors and an overall varnish for dynamic effect.

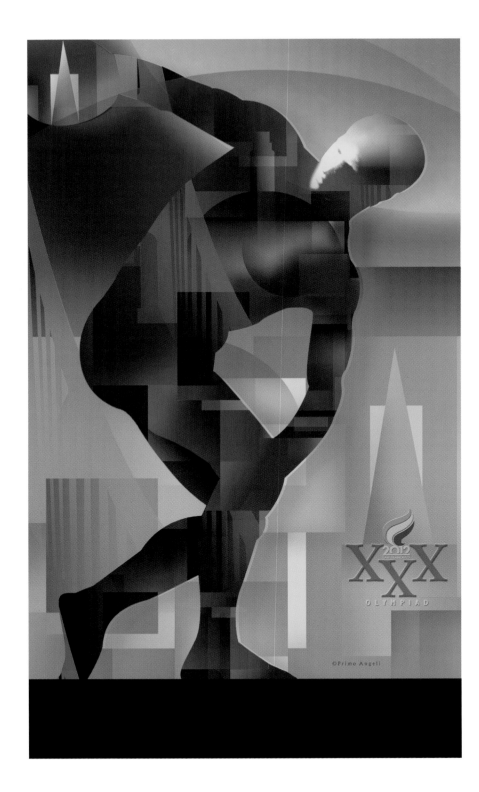

"For me, the fine arts, contemporary and classic, inspire and resonate substance and duration."

— PRIMO ANGELI

STUDIO
Primo Designs

ART DIRECTOR/DESIGNER
Primo Angeli

ILLUSTRATORS
Primo Angeli, Ryan Herras, Ryan Medieros, Kirsten Angeli

CLIENT
Anne Cribbs, CEO, San Francisco U.S. Bid City 2012 Olympic Games

SOFTWARE
Adobe Illustrator, Adobe Photoshop

PAPER
Centura Matte, 100 lb. book

PRINT RUN
5000

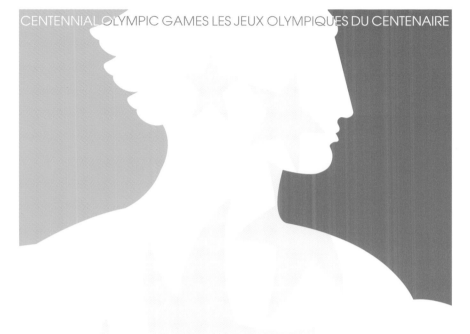

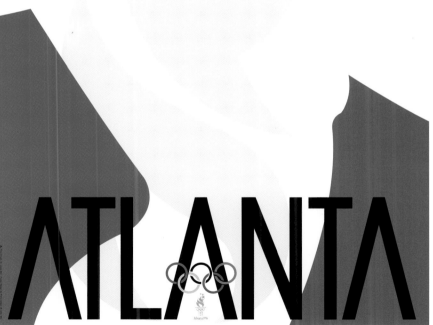

STUDIO
Primo Designs

ART DIRECTOR/DESIGNER
Primo Angeli

ILLUSTRATORS
Mark Jones, Marcelo DeFreitas

CLIENT
Atlanta Committee for the
Olympic Games

SOFTWARE
Adobe Photoshop,
Adobe Illustrator

COLORS
5, plus varnish

<

POSTER FOR THE 100TH ANNIVERSARY OF THE OLYMPICS AND THE ATLANTA GAMES

"I USED THE GRECIAN FIGURE SCULPTURE to represent the origin of the modern day Olympics and neutralize the multi-racial concerns," says Primo Angeli, noting that the poster also pays homage to the 100th Anniversary of the modern day Olympics. The word "Atlanta" was hand-drawn.

[SOURCE OF INSPIRATION]

■ "I often go back to the master painters and printmakers for inspiration," says Primo Angeli.

> LEARJET NBAA INVITATION

BLANK GOTHIC TYPEFACE, STYLIZED
illustrations of the 1920s, crisp clean lines,
and a palette of gold, black, red and white
all contribute to making this invitation
evocative of the art deco period, which
had its heyday in the 1920s and 1930s. The
lines of the invitation are almost architec-
tural in nature, and the innovative folds
and die cuts enliven the piece with plenty
of style inspired by a movement that
heavily influenced art, architecture,
furniture design and much more.

[SOURCE OF INSPIRATION]

■ **Art deco period architecture**

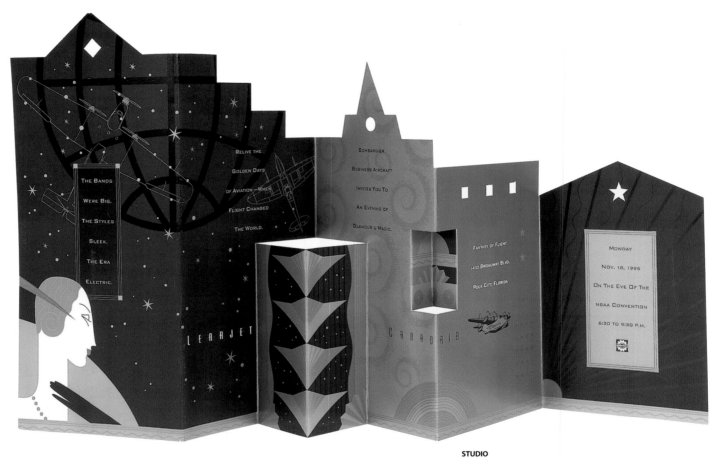

STUDIO
Greteman Group

ART DIRECTOR
Sonia Greteman

DESIGNERS
Sonia Greteman, James Strange

CLIENT
Bombardier Learjet

PAPER
Warren Lustro Dull

COLORS
7 match colors

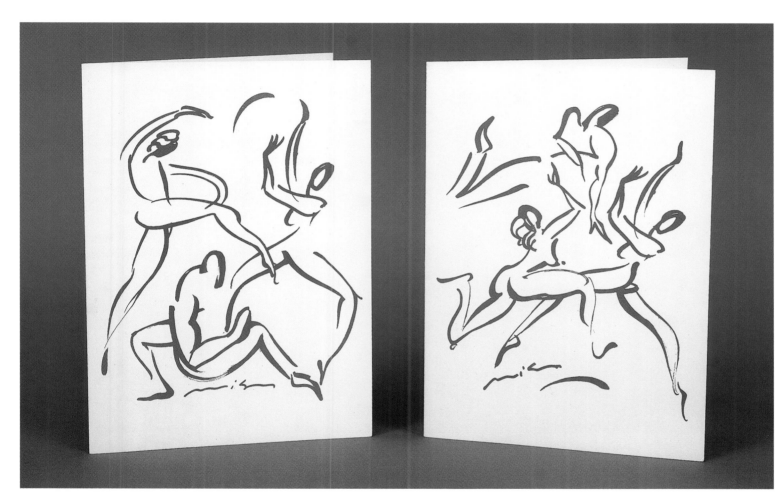

WILD DANCE GREETING CARDS

DANCE UMBRELLA, A NEW ENGLAND-based nonprofit organization of contemporary and culturally diverse dance, asked Misha Lenn to create a design that could be translated to blank greeting cards, T-shirts, and of course, umbrellas. Befitting the organization's purpose, Lenn created this one-color free-form dance visual that was inspired by the works of Matisse.

"His definitive works, *Dance* and *Music*, are influential for many artists in the world, including me," says Lenn.

[SOURCES OF INSPIRATION]

■ **Henri Matisse, French impressionist artist (1869–1954)**
■ **"World of Art" movement including *The Russian Seasons* in Paris**

STUDIO
Misha Design Studio

ART DIRECTOR/ILLUSTRATOR
Misha Lenn

CLIENT
Dance Umbrella

>

CARE FUTURE LOGO AND STATIONERY PROGRAM

"THE LOGO MARK PAYS HOMAGE TO Russian constructivist art through the illustration of a person waving a flag overhead," says John Hornall, art director. "This venture capital group was looking to revolutionize the whole idea of healthcare and wanted an identity that would reflect that type of revolutionary thinking. Specifically, they wanted to promote the empowerment of Americans as healthcare consumers. The client cited Vaclav Havel, a Czech playwright and political dissident, as their inspiration for the idea of revolution in relation to how people think, instead of a revolution through force."

[SOURCE OF INSPIRATION]

■ **Vaclav Havel, president of the Czech Republic and playwright (born 1936)**

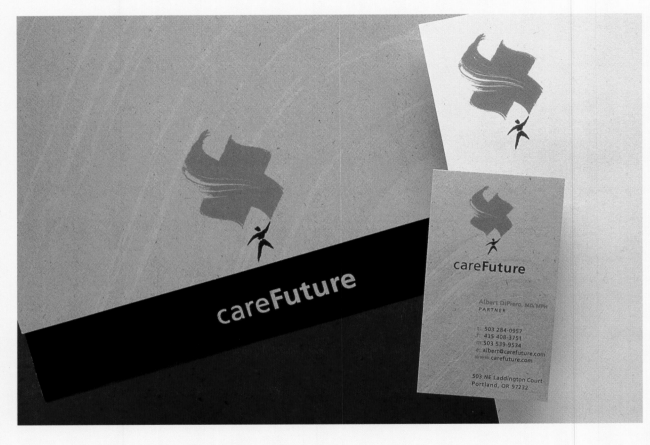

STUDIO
Hornall Anderson Design Works

ART DIRECTOR
John Hornall

DESIGNERS
Jana Wilson Esser, Hillary Radbill, Sonja Max, Michael Brugman

CLIENT
Care Future

PAPER STOCK
Speckletone Kraft 100 lb. cover

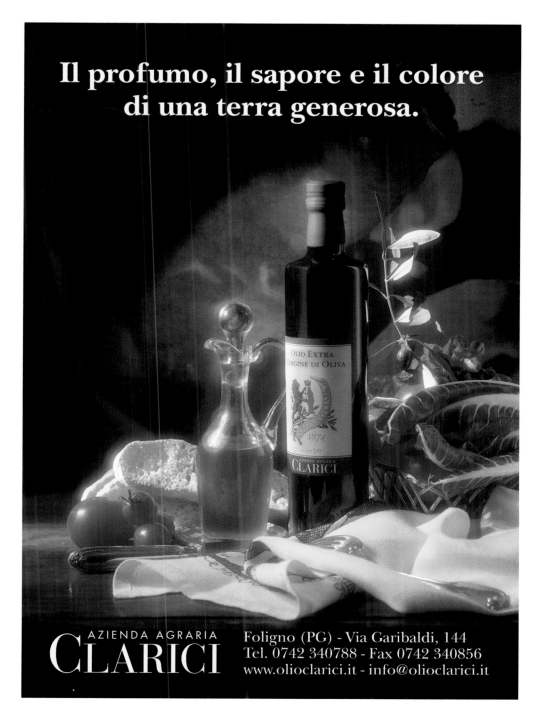

STUDIO
Studio GT&P

ART DIRECTOR
Gianluigi Tobanelli

PHOTOGRAPHER
Vincenzo Capacci

CLIENT
Azienda Agraria Clarici

SOFTWARE
Adobe Photoshop, FreeHand

<

CLARICI EXTRA VIRGIN OLIVE OIL POSTER

WHEN DESIGNERS SET OUT TO CREATE A poster for Clarici Extra Virgin Olive Oil, they wanted an image that was visually strong. They also wanted it to be evocative of wholesome food while reminding consumers of the product's longstanding tradition and history.

For inspiration, they turned to the painter Caravaggio, a renowned painter of the Italian Renaissance. "In his works, the background almost disappears," says Gianluigi Tobanelli, art director on the project. "The shades are almost black and contrast with the lights, which are very strong. So framed and focused, reality comes nearer the viewer and the contrasts become sharper."

According to Tobanelli, Caravaggio's works were especially apropos because he was the first Italian artist to paint still lifes and often, he placed fruits and flowers near the human figures.

[SOURCE OF INSPIRATION]

- **Caravaggio, Italian artist (1571–1610) (Also known as Michelangelo Merisi da Caravaggio.) Some of his paintings include *David With the Head of Goliath*, *Madonna of the Rosary*, *Death of the Virgin*, and *St. John the Baptist in the Wilderness*.**

> ANNETTE FARRINGTON AZURE WONDER & LUST CD

"I HAVE BEEN A FAN OF FINE ARTIST Randal Thurston's work for a long time—it hangs in our studio," says Clifford Stoltze, Stoltze Design. "In fact, when I heard Annette's music with its references to music and life, I introduced Annette to his work and she agreed it was perfect. So we asked him to create a piece for the project that was used in its true form, but he also gave us the license to manipulate the artwork so we sometimes layered it with related images to give it added depth."

As a finishing touch, the art was slipped inside a purple-tinted jewel case.

[SOURCE OF INSPIRATION]

■ **Randal Thurston, American artist**

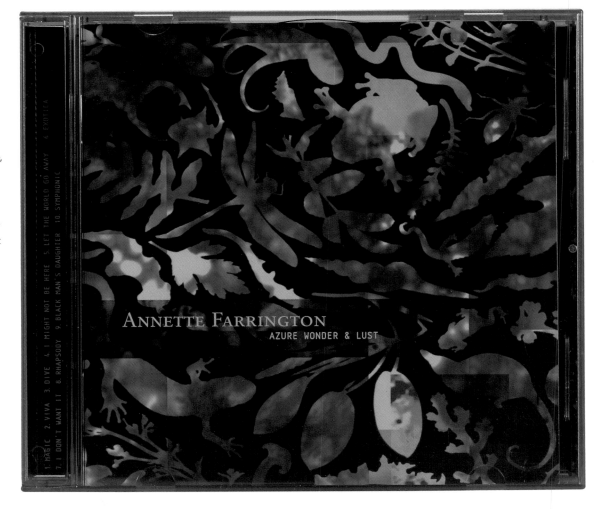

STUDIO
Stoltze Design

ART DIRECTOR/DESIGNER
Clifford Stoltze

ILLUSTRATOR
Randal Thurston

PHOTOGRAPHER
Craig McCormack

CLIENT
Castle von Buhler Records

PAPER STOCK
Arjo Wiggins Canson Satin

COLORS
4 colors over 2

PAGES
16

SIZE
4³/₄" x 4³/₄" (12 cm x 12 cm)

STUDIO
2cdesign

ART DIRECTORS
Christine Guiang, Chris Esworthy

DESIGNER
Christine Guiang

CLIENT
2 by 2 for Aids and Art

PAPER STOCK
Mohawk Ultrawhite
Superfine Smooth

<

2 BY 2 FOR AIDS AND ART LETTERHEAD SYSTEM

2 BY 2 IS A NONPROFIT ORGANIZATION that benefits the American Foundation for AIDS Research and the Dallas Museum of Art. To raise funds, the organization hosts silent and live auctions featuring contemporary art donated by artists from around the world.

"With this in mind, I wanted the logo to be more than just a mark; I wanted it to be a piece of artwork based on some of the same theories as contemporary art…thought provoking and conceptual," says Christine Guiang, art director and designer on the project. "When the viewer looks at the logo, I want their mind to create what he or she wants the art to be. I want it to be subjective, meaningful, and unique for everyone.

"In creating this logo, I relied on the practices of many artists and styles of art: dada, Marcel Duchamp, minimal art, Donald Judd, Bauhaus art and Josef Albers. All of these artists recognized self-expression and the concept of minimalism. The logo is a conceptual representation of the event, its involvement with AIDS, and contemporary art."

[SOURCES OF INSPIRATION]

- **Donald Judd, American sculptor (1928–1994)**
- **Joseph Albers, German-American designer (1888–1976)**
- **Museum of Modern Art, New York (www.moma.org)**
- **Guggenheim Museum, New York (www.guggenheim.org)**
- **The Rachofsky House, Dallas, Texas**
- **Dallas Museum of Art, Dallas, Texas (www.dm-art.org)**
- ***Modern Art: Painting, Sculpture, Achitecture* by Sam Hunter and John Jacobus**

> DEAD MAN WALKING FLAT MAILER

HANDLETTERING IN CRAYON GIVES THE distinctive look to this mailer promoting the film *Dead Man Walking*. Mike Salisbury borrowed from the style of Basquiat to achieve the look—a rough, graffiti-like quality—that he was after.

[SOURCES OF INSPIRATION]

- *The Smithsonian* magazine
- Jean-Michel Basquiat, American artist (1960–1988)

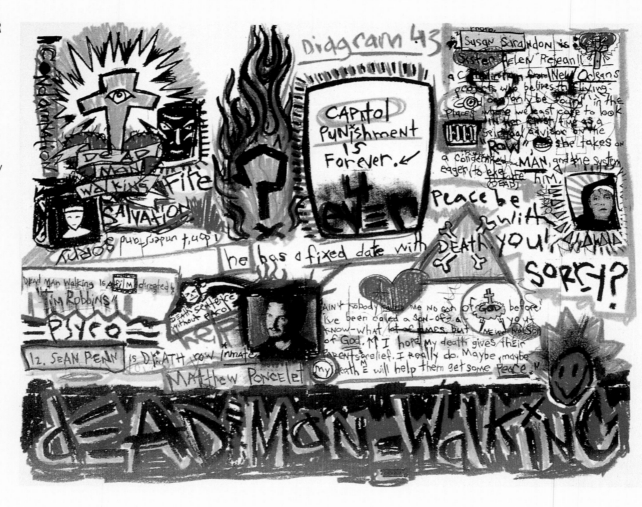

STUDIO
Mike Salisbury LLC

ART DIRECTOR
Mike Salisbury

DESIGNERS
Mike Salisbury, Doyle Harrison

ILLUSTRATOR
Doyle Harrison

CLIENT
Polygram Films

COLORS
4-color process

SIZE
8¹⁄₂" x 11" (22 cm x 28 cm)

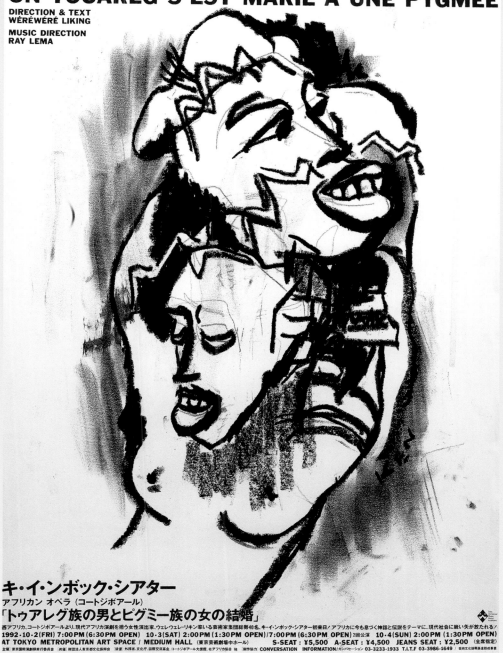

STUDIO
Kenzo Izutani Office Corporation

ART DIRECTOR
Kenzo Izutani

DESIGNERS
Kenzo Izutani, Aki Hirai

ILLUSTRATOR
Kenzo Izutani

CLIENT
Conversation & Company
Limited

PAPER STOCK
New Age 135 kg

PRINT RUN
500

<

KI-YI M'BOCK POSTER

DRAWINGS BY JEAN-MICHEL BASQUIAT and the book *Basquait Drawings* provided the inspiration for this poster for the play Ki-Yi M'Bock. Kenzo Izutani, art director, designer and illustrator, gave the style his own interpretation in this two-color rendition.

[SOURCES OF INSPIRATION]

- **Jean-Michel Basquait, American artist (1960–1988)**
- *Basquiat* **by Richard Marshall, Robert Marshall, Robert D. Thompson (contributor)**

>
MASS MEDIA

TO CREATE THIS SIX-PART SELF-PROMO piece, Janice Lowry tapped into her background in fine arts because "that seems to be one of the most rewarding and richest areas of inspiration," she says. Specifically, she was inspired by Joseph Cornell and Marcel Duchamp; "the ones that do art from their own inner inspiration," says Lowry. For this project, entitled *Mass Media*, Lowry collected dozens of images and assembled them collage-style into a series of six vignettes, including everything from black-and-white photographs, vintage line art, newspaper clippings and advertising to obscure medical diagrams.

She pulled the whole project together using only a craft knife, scissors, and lots of spray mount.

[SOURCES OF INSPIRATION]

- **Joseph Cornell, American artist (1903–1972)**
- **Marcel Duchamp, French-American artist (1887–1968)**

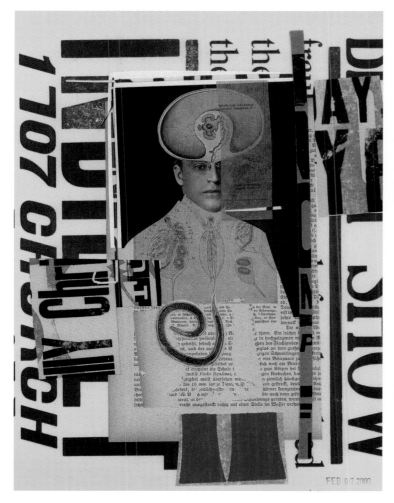

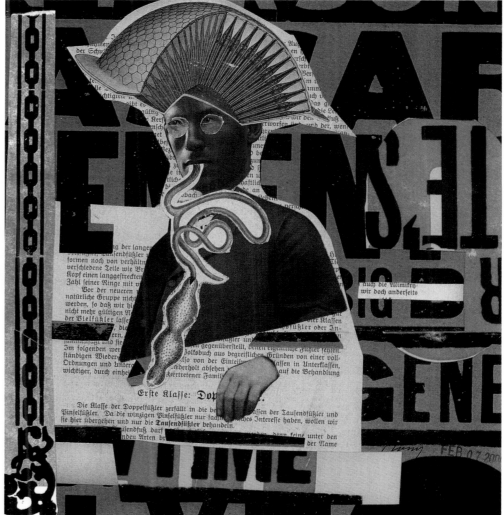

STUDIO
Lowry Studio

**ART DIRECTOR/DESIGNER/
ILLUSTRATOR**
Janice Lowry

CLIENT
Janice Lowry

PAPER
Antique

"My favorite sources [of inspiration] are

museums…you look at original, obscure works

of arts and then as you go inside the museum or

gallery, you can really see the source of the vision."

— J A N I C E L O W R Y

> ## CENTRAL PENNSYLVANIA FESTIVAL OF THE ARTS POSTER

LANNY SOMMESE HAS DESIGNED posters for the Central Pennsylvania Festival of the Arts for nearly thirty years. Each year's challenge is to capture the spirit and emotion of the event while coming up with a fresh new design. "Fortunately, my client asks only that I give a fresh look to the content each year and that I don't revisit a stylistic bent more than once every five or six years," says Lanny Sommese. "In order to not appear redundant stylistically, I have challenged myself to be as various as possible in my image-making approach. The result is that the inherent vocabularies of paint, pencil, pastel, paper—as well as the computer— have all somehow found their way onto the Festival posters."

Sommese decided to give a surrealist look to this poster because it parallels the melee of activity brought about by more than 100,000 Festival attendees—artists, performers, festival-goers, and vendors— that converge on State College. The only direction Sommese received from the client was a loose directive to hint at the new millennium, which Sommese accomplished by having the jester, representing the arts, nearing the top of the steps

where the sun is shining.

Sommese photocopied images out of old source books and assembled the collage by hand. Once the image was scanned into the computer and cleaned up, Sommese added the type. Then, he printed the image using an ink-jet printer and added watercolors by hand.

[SOURCES OF INSPIRATION]

- *Une Semaine de Bonté: A Surrealistic Novel in Collage* by Max Ernst
- *The Clip Art Book* by Gerald Quinn
- *Music, A Pictorial Archive of Woodcuts & Engravings* by Jim Harter
- *1800 Woodcuts by Thomas Bewick and his School* by Blance Cirker
- *Decoupage: The Big Picture Sourcebook* edited by Hasbrouck Rawlings
- *Handbook of Early Advertising Art* by Clarence P. Hornung
- *Dada, Surrealism, and Their Heritage* by William S. Rubin
- *Dada & Surrealism* by Robert Short
- *Collage* by Herta Wescher
- *René Magritte* by A.M. Hammacher

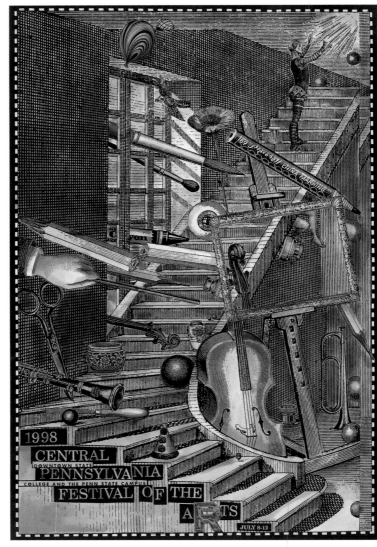

STUDIO
Sommese Design

ART DIRECTOR/ILLUSTRATOR
Lanny Sommese

CLIENT
Central Pennsylvania Festival of the Arts

SOFTWARE
Adobe Illustrator

PAPER
Mohawk Tomahawk

COLORS
4-color process

SIZE
24" x 36" (61 cm x 91 cm)

PRINT RUN
2500

COST PER UNIT
$1.50 U.S.

"I felt that the obvious painterly 'hand-done' quality of the added color gave a human feel to the image. It made it look more arty, too."

—LANNY SOMMESE

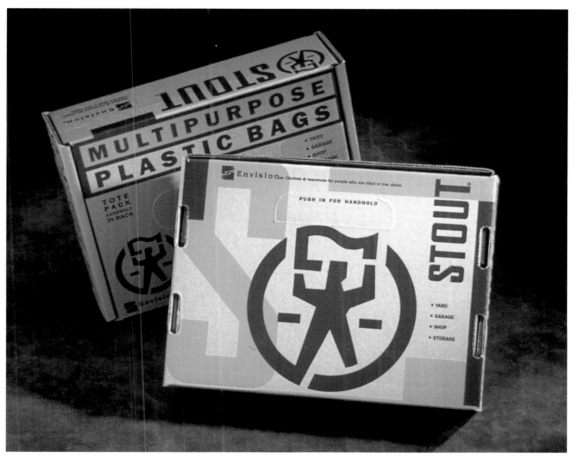

STUDIO
Greteman Group

ART DIRECTORS
Sonia Greteman, James Strange

DESIGNER
James Strange

CLIENT
Envision

PAPER
Cardboard

COLORS
2 match colors

PRINT RUN
50,000

<

STOUT PACKAGING

ART AND CRAFTSMANSHIP, THE HALL-
marks of the Bauhaus style, are notable
in this packaging for multipurpose plastic
bags. Popular during the years 1919
through 1933, the Bauhaus movement
is characterized by its logical and formal
structure. Designers opted to mimic this
look because the product is tough—and
the utilitarian feel of the logo supports the
concept of tough and industrial.

[SECTION]

2

Online resources for inspiration from illustrations

www.shag-art.com

www.artcyclopedia.com

www.societyillustrators.org

www.stockart.com

OR VISIT THESE ONLINE MUSEUMS...

The Art Institute of Chicago (www.artic.edu)

E.G. Bührle Collection, Zurich, Switzerland (www.buehrle.ch)

Museum of Fine Arts, Boston (www.mfa.org)

San Diego Museum of Art (www.sandiegomuseum.org)

The State Hermitage Museum, St. Petersburg, Russia (www.hermitagemuseum.org)

Van Gogh Museum, Amsterdam (www.vangoghmuseum.nl)

Metropolitan Museum of Art, New York (www.metmuseum.org)

inspired by → [illustration]

Illustrations provide designers with a great variety of pieces from which they can draw their inspiration. Suggestions for where to dig for ideas include everything from high-end magazines such as *Harper's Bazaar*, *Vogue*, and *The New Yorker* to vintage advertising, motel signs, pin-up posters, matchbook covers, pulp novels, cartoons, and propaganda posters. The sources are seemingly endless.

One may choose to take the more traditional route paved by such noted illustrators as Henri Toulouse-Lautrec and Norman Rockwell, or one may choose to follow in the footsteps of more nontraditional illustrators. The distinctive style of American James Montgomery Flagg (1877–1960) immortalized the United States government's Uncle Sam with his proclamation: "I Want You for the U.S. Army," while Dutch illustrator M.C. Escher (1898–1972) became famous for his optical artwork where staircases go neither up nor down.

ILLUSTRATION 59

what inspires you?

misha Lenn

"I like the impressionists. They are my heroes, my idols: I love them. Degas, Renoir, Lautrec, all of them," says Misha Lenn, whose style of illustration—mixing pen and ink with watercolors—has won him international acclaim and reflects the influences of the impressionists.

Born in St. Petersburg, Russia, Lenn first visited the United States out of curiosity but later decided to make Boston his second home. In 1990, he was granted a visa "for persons with extraordinary ability in science or in art," which allowed him to live in the U.S. permanently.

An accomplished jazz pianist as well as an acclaimed artist, Lenn's work shows the parallels between music and art, his two loves. "I've played jazz all my life," he says. "It reflects myself and reflects my art. The same feelings go through life from music to art.

"Everything connected to music or dance appeals to me," he says of his sources of inspiration. "I don't think about how it works in my mind. It clicks. When something clicks, it is like a series, one thing goes after another. I have so many ideas and so many things I want to do, but physically, I am not capable of doing them all."

When an idea doesn't click, Lenn may get involved personally. One time when he was asked to design an invitation, he took tango lessons himself to capture the feel for the dance, and then he was able to present two people dancing the tango on the invitations.

"An idea starts from a very little thing—just like how a pearl grows. It is a tiny thing that grows inside the shell, which means I'll have a little idea, but it grows and grows. It is truly interesting that it goes from a small little thing to a big series of somethings."

Lenn's work takes on the characteristics of two genres: fine art and illustration. He works to combine characteristics of impressionism—emotions, movements, and colors—with styles from more decorative artists like Gustav Klimt, which make one look at a painting as though it were through a curtain.

Lenn's work usually does not include faces or features. He hints at an eye or a nose, but uses body presentation for most of the communicating because, he says, "The body speaks for itself. You can say everything by just putting a hand on one side or another."

He'll thumb books and magazines to collect images and emotions for projects. "It's like giving birth," he says. "When I'm doing something for a musical piece, I will listen to music; if it is a particular style, like Toulouse-Lautrec, I'll look at his paintings.

"Movies and fine art are everywhere. Illustration is not as visible. An illustrator is a person who translates something. Fashion designers are great illustrators," adds Lenn, citing Yves St. Laurent and Coco Chanel as two fashion designers who inspire his illustrations. "Everything, all forms of art are connected to one another."

To learn more about Misha Lenn's work, visit www.mishalenn.com.

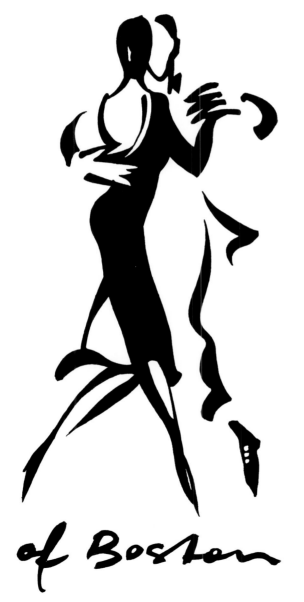

<

THE TANGO SOCIETY OF BOSTON

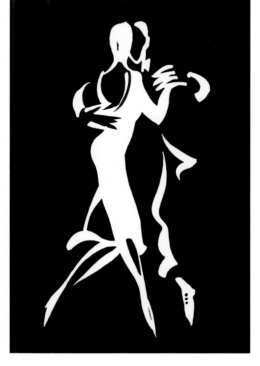

THE TANGO SOCIETY OF BOSTON teaches the tango and wanted a logo that captures the feeling of this sensual dance. Using the fluid rendering technique for which he is known, Misha Lenn used illustration to capture the energy of the tango. His inspiration came from the natural artistry of movement in the body, especially dancer and actor Pablo Veron.

STUDIO
Misha Design Studio

**ART DIRECTOR/DESIGNER/
ILLUSTRATOR**
Misha Lenn

CLIENT
The Tango Society of Boston

COLORS
1-color

ILLUSTRATION 61

> FOSSIL RAZOR BLADE TINS

FOSSIL, WHICH IS A COMPANY ALMOST as well-known for its unique vintage watch packaging as for its watches, turned to the illustration style of razor blade packaging from the 1940s and 1950s to dress up its tins. A muted color palette is integrated with a variety of typefaces including Alternate Gothic, Din Engshrift, Ribbon, Franklin Gothic, Interstate, Script MT, and Freehand 521. Jonathon Kirk, the designer, manually altered some existing type, using it alongside some hand-drawn typefaces based on the classic packaging.

[SOURCES OF INSPIRATION]

- **Letterpress/block printing**
- **Screen printing**
- **1940s, 1950s and 1960s advertising**
- **Antique packaging for soda, motor oil and gas station products**
- **Motel signs**
- **Hot rods**

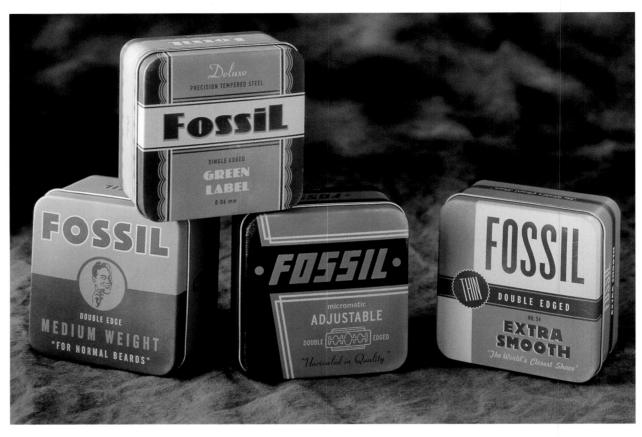

STUDIO
Fossil

ART DIRECTOR
Stephen Zhang

DESIGNER
Jonathan Kirk

PHOTOGRAPHER
David McCormick

CLIENT
Fossil

SOFTWARE
Adobe Illustrator, Adobe Photoshop

COLORS
4-color process

PRINT RUN
15,000

COST PER UNIT
$.028 U.S.

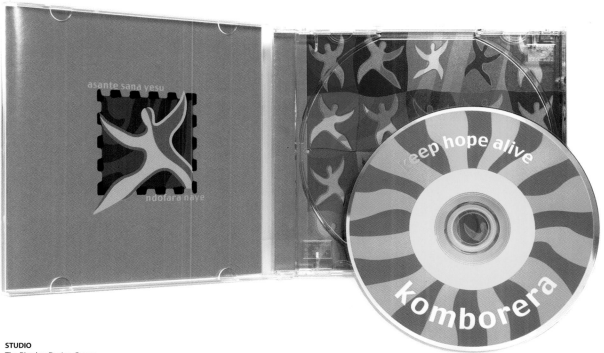

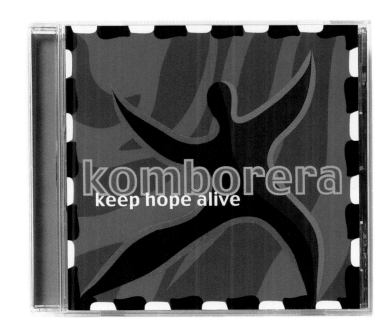

STUDIO
The Riordon Design Group

ART DIRECTOR
Ric Riordon

DESIGNER
Blake Morrow

ILLUSTRATOR
Dan Wheaton

CLIENT
Kean & Company Inc.

SOFTWARE
Adobe Illustrator, QuarkXPress

PAPER
Coated stock

COLORS
4 over 4-color process

SIZE
Standard CD jewel case
(3 panel rollover)

PRINT RUN
5000

COST PER UNIT
$20.00 U.S.

<

KOMBORERA CD PACKAGING

BECAUSE THE MUSIC ON THIS CD WAS
recorded in Africa and Nashville, The
Riordon Design Group Inc. decided that
an illustration inspired by textiles from
the region of Africa where the artists origi-
nated would be fitting artwork for the
packaging. They incorporated a warm
color palette indigenous to the region.
The resulting packaging conveys energy
and hope—in keeping with the title of
the CD, which in Shona, a language
spoken by more than nine million people
in Zimbabwe, means *bless*.

[SOURCES OF INSPIRATION]

■ **Textiles or fabrics inspired by Africa**
■ *Communication Arts Illustration Annual*
■ *The Illustrators (The British Art of
 Illustration 1800–2001)*, **Chris Beetles
 Limited**

ILLUSTRATION **63**

>

GOTCHA SPORTSWEAR
1960S JEANS

WHAT MORE FITTING INSPIRATION AND treatment for Gotcha Sportwear's line of 1960s revival jeans is there than psyche-delic art? So thought Mike Salisbury, director and designer for this project. Illustrator Pam Hamilton produced the design as a single piece of artwork, using watercolors and hand-lettered type.

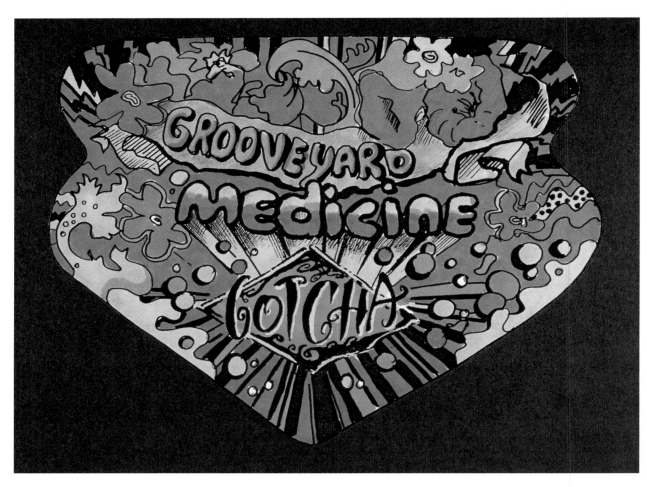

STUDIO
Mike Salisbury, LLC

ART DIRECTOR/DESIGNER
Mike Salisbury

ILLUSTRATOR
Pam Hamilton

CLIENT
Gotcha Sportswear

COLORS
4-color process

SIZE
5" x 7" (13 cm x 18 cm)

PRINT RUN
50,000

STUDIO
Primo Designs

ART DIRECTOR/DESIGNER
Primo Angeli

ILLUSTRATORS
Primo Angeli, Rene Yung,
Tandy Belew

CLIENT
Boudin Bakery

PAPER
Warren Dull Coat

COLORS
4-color process

PRINT RUN
10,000

<

BOUDIN BAKERY POSTER

SAN FRANCISCO'S BOUDIN BAKERY, famed for its sourdough bread, asked Primo Angeli to create a poster that would conjure up images of its tradition and 150-year heritage in breadmaking. With that in mind, Angeli drew inspiration from 19th century typefaces and illustration of that period, which possessed traditional handmade nuances. When used in this poster, they accurately reflect an old-style, handmade product.

[SOURCES OF INSPIRATION]

- Classic typography
- Illustrations found on storefront signage and kiosks in 19th century Paris
- Fine arts—contemporary and classic

ILLUSTRATION 65

>

ENJOY MUSIC POSTER

THIS POSTER WAS DESIGNED AS A SALES item to raise money for the Student Music Club at Pennsylvania State University, so it needed to appeal to as wide an audience as possible. With that in mind, designer Lanny Sommese opted to approach the project much the way Saul Steinberg would—employing humor because of its universal appeal.

"It has been said that Steinberg's imagery crosses the borders between art and illustration, cartoon and satire. Most important to me is his sense of humor— in another life he had to be a stand-up comic—and his deft ability to manipulate the relationships between the verbal and the visual, especially in his use of puns and double-entendre," says Sommese.

Making humor a paramount element of the design, Sommese created the poster with the idea that humor can open a dialogue with the viewer, and as a result, induce them to purchase the poster. "Additionally, like Steinberg, I wanted my drawing to present the idea clearly because getting the relationship between the verbal and visual is crucial."

[SOURCES OF INSPIRATION]

■ **Saul Steinberg, Romanian-American illustrator (born 1914)**
■ ***The Labyrinth* by Saul Steinberg**
■ ***The Catalogue* by Saul Steinberg**
■ ***The Inspector* by Saul Steinberg**
■ ***The New World* by Saul Steinberg**
■ ***Saul Steinberg Commentary* by Harold Rosenberg**

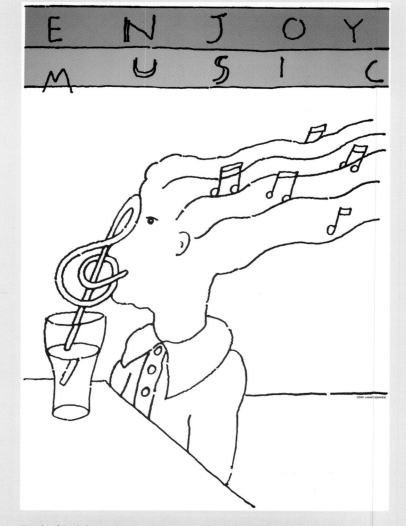

"Each of Steinberg's images appears to flow effortlessly from an idea—an idea that sprouts directly from the human condition. In effect, the hearts and minds of Steinberg's audience—their day-to-day personal and social experiences—are his sources...He's a social scientist with his finger on the collective American pulse. Finally, I appreciate Steinberg's direct approach to making his visual statements. He's frugal—all that is not essential to expressing the concept is eliminated and, unlike many of his contemporaries, his stylistic approach presents the idea without interfering with the message,"

— LANNY SOMMESE

STUDIO
Sommese Design

ART DIRECTOR/ILLUSTRATOR
Lanny Sommese

CLIENT
The Student Music Club,
Pennsylvania State University

SOFTWARE
Adobe Illustrator, Adobe Streamline

PAPER
Epson Heavyweight Matt

COLORS
3 match colors

SIZE
24" x 36" (61 cm x 91 cm)

PRINT RUN
42

COST PER UNIT
$8.00 U.S.

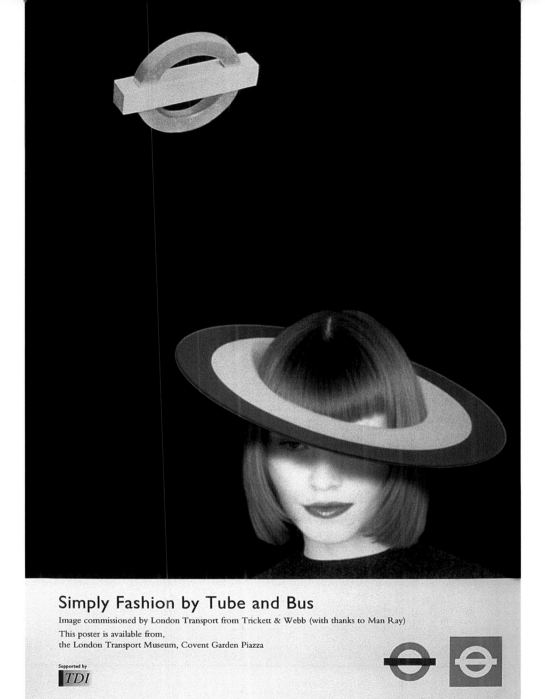

SIMPLY FASHION

STUDIO
Trickett & Webb Limited

DESIGNERS
Lynn Trickett, Brian Webb,
Marcus Taylor

CLIENT
London Transport

PAPER
MG Poster

COLORS
4-color process

SIZE
25" x 40" (64 cm x 102 cm)

PRINT RUN
1500

Simply Fashion by Tube and Bus

Image commissioned by London Transport from Trickett & Webb (with thanks to Man Ray)

This poster is available from,
the London Transport Museum, Covent Garden Piazza

Supported by
TDI

THE DESIGNERS AT TRICKETT & WEBB
Limited were asked to create a poster to
appear in London's underground stations
during Fashion Week.

"In order to link fashion with London
Transport, we took an archive poster Man
Ray produced for London Transport in the
1930s and gave it a contemporary twist
by turning the central image into a smart
young girl in a hat based on the London
Transport roundel," says Lynn Trickett. "The
original poster is extremely rare, valuable,
and unobtainable. This was the closest we
could ever get to owning it!"

[SOURCES OF INSPIRATION]

- **Tate Modern**
- **Serpentine Gallery**
- **National Portrait Gallery**
- **Man Ray, American surrealist
 photographer and painter (1989–1976).
 Also known as Emmanuel Rudnitsky.**

ILLUSTRATION **67**

> MOMENT IN TIME™ COLLECTION

TWO DESIGN FIRMS COLLABORATED TO develop the beautifully illustrated faces of these five clocks that literally capture a "moment in time," as well as some of the history of illustration. For the most part, the designers took vintage illustrations from a stock library and doctored them up in Adobe Photoshop to create the exact look they sought.

[SOURCES OF INSPIRATION]

- Folk art
- Old advertising posters
- Illustrations popular in antiques
- John James Audubon, American naturalist and illustrator (1785–1851)

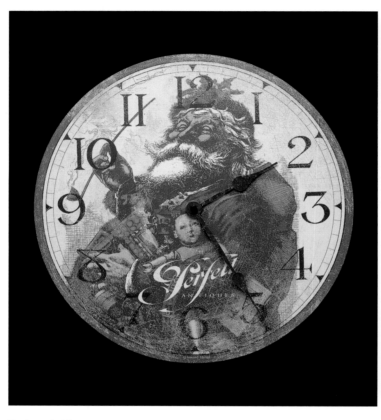

The Santa clock face was a black-and-white illustration before designers put it into Photoshop and applied washed-out hues by under-layering. It was inspired by the Coca Cola advertising campaign of the 1920s and 1930s, which pictured Santa holding a Coke.

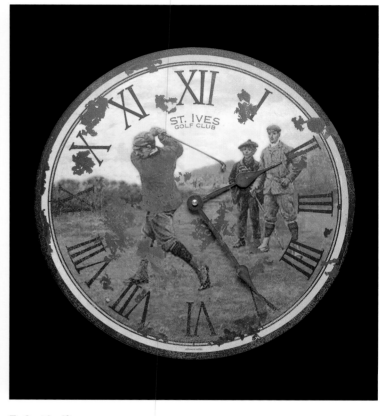

The Scottish golf image was purchased and then scuffed up by layering effects of old flaking, rusting metal chips. This image is reminiscent of illustrations used by British Railways to promote tourism to various destinations, including the St. Andrews Golf Course in Scotland. These posters are almost as famous as the luxury steamship posters of the 1920s.

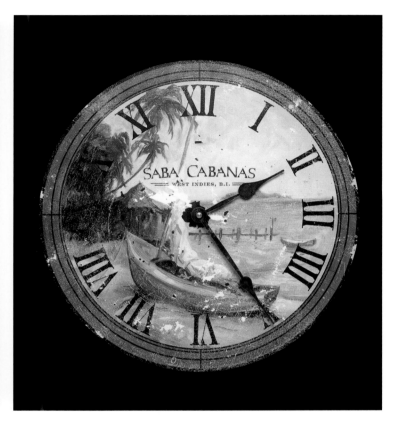

"The Saba Cabanas face was fashioned from a painting in my personal collection by a folk artist in town," says Gregg Palazzolo, who is based in Ada, Michigan. "We tried to replicate the work of an uneducated island artist that may have painted on any one of several British Virgin Isles during Hemingway's trips south. The font was tweaked from a blip font package and the outer rings were created in Illustrator."

Unlike the other clock faces in the collection where the imagery was printed and laminated to masonite or MDF board, the oil illustration for the background of the Saba Cabanas clock was applied to a tin canvas.

"It is tough to create an acceptable image to sell to a client. The Saba Cabanas clock face was an instance where we were able to sell this concept. I love and collect folk or indigenous artworks from Cuba, Romania, Russia and the United States. I respect and admire the fresh alternative to tight commercial work that these artists are able to conjure up," says Palazzolo.

Designers wanted to give this clock an old Audubon image (the kind that is often found in antique shops), so they purchased a stock image of a hydrangea. The background has been photographed, and the designers layered in a slightly modified font.

ILLUSTRATION **69**

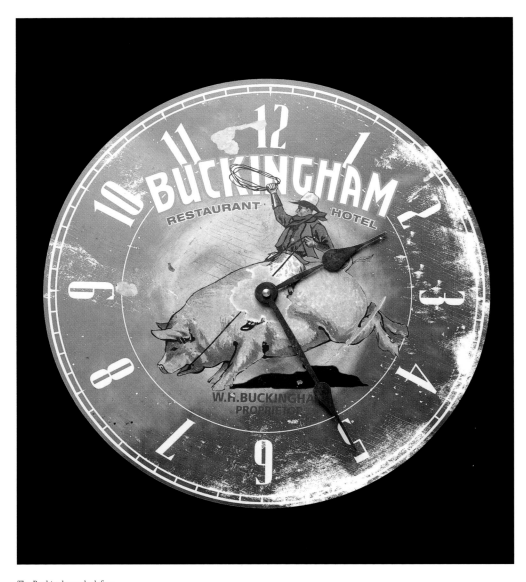

"Digital manipulation is a bridge in recreating old hand-drawn type. I collect old items, books, tins, magazines and signs with lost typefaces or hand drawn lettering. And I love the fact that I can scan and rework old masterpieces of type with today's technology and software programs."

— GREGG PALAZZOLO

STUDIO
Palazzolo Design Studio in conjunction with The Jager Group

ART DIRECTORS
Gregg Palazzolo, Tom Crimp (The Jager Group)

DESIGNER
Brad Hineline

ILLUSTRATORS
Gregg Palazzolo, Brad Hineline, and Roger Timermanis (The Jager Group)

CLIENT
Howard Miller™ Clock Company

SOFTWARE
Adobe Illustrator, Adobe Photoshop

COLORS
4-color process

SIZE
13¼" x 13¼" (33.5 cm x 33.5 cm)

The Buckingham clock face was inspired by old throwback Southside Chicago neighborhood restaurants. "We used a stock illustration and modified it with a reworked font. It created a burnished effect, overall," explains Palazzolo.

> BELLE EPOQUE VISUAL IDENTITY

"WE WANTED THIS FILM IDENTITY TO look like a re-creation of designs from the 1920s and 1930s, the time in which the action of the film takes place," says Jorge Garcia, art director and illustrator. He composed the film's title, Belle Epoque, in a digitally created font inspired by shop signs and advertising from that era.

"Although this was a time full of conflicts for Spain, the film is a comedy that reflects the optimistic mood of the Spanish people, who received the new republic with enthusiasm. We were sure to use illustration that resembled a style popular in Spain during those years—a style that was common in film, carnival, and political posters, as well as in advertising. Color and typography were worked in a more contemporary fashion."

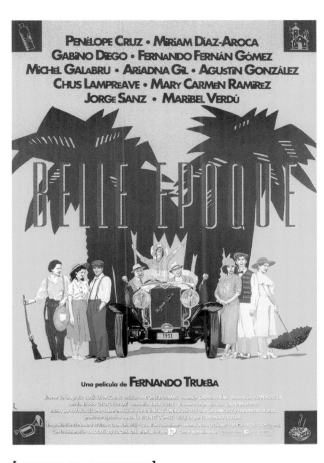

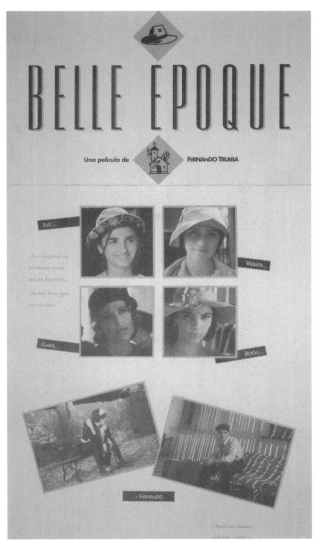

[SOURCES OF INSPIRATION]

- **Vorticist artists**
- **Paul Klee, Swiss expressionist painter (1879–1940)**
- **Hans Arp (Jean Arp), German French dadaist (1887–1966)**
- **Spanish surrealists**
- **Ralston Crawford, American precisionist painter (1906–1978)**
- **Charles Sheeler, American precisionist painter and photographer (1883–1965)**
- **Architecture from the 1920s and 1930s**
- **Rafael de Penagos, Salvador Bartolozzi, and Manolo Prieto, Spanish illustrators**
- **The Russian avant-garde movement**

STUDIO
Tau Diseño

ART DIRECTOR/ILLUSTRATOR
Jorge Garcia

CLIENT
Fernando Trueba P.C.

PAPER STOCK
White offset

COLORS
4-color process

PRINT RUN
10,000

ILLUSTRATION 71

TARGET MARGIN THEATER 2000-01 SEASON BROCHURES

CHRISTOPHER MARLOWE IS AN Elizabethan playwright; Philip Marlowe is a character in numerous mystery novels written by Raymond Chandler during the 1930s. The similarity between the names led to some confusion in early design sessions, when ALR Design sat down to develop direct mail brochures promoting the Target Margin Theater's upcoming season of Marlowe's plays. This confusion gave birth to inspiration.

The first brochure was printed four over one to save costs, but when the budget increased later, the interior spread was printed in four colors as well.

[SOURCES OF INSPIRATION]

■ **Vintage book covers, magazines, and comic books**

Using a style of illustration popularized with 1930s mysteries—imitating the thrilling, cliffhanger style of the vintage covers with their vivid, deeply saturated color palette and traditional typefaces—ALR Design gave a new look to Marlowe's plays. The artwork is also aged to look like an oft-thumbed tome a book lover would be happy to find in an antique store.

"The lurid cover illustrations for 1930s and 1940s pulp magazines seemed the perfect way to represent the details of Elizabethan playwright Marlowe's dramatic work," says Noah Scalin, art director, designer and illustrator on this project.

STUDIO
ALR Design

ART DIRECTOR/DESIGNER/ILLUSTRATOR
Noah Scalin

CLIENT
Target Margin Theater

SOFTWARE
QuarkXPress, Adobe Photoshop, Adobe Illustrator

COLORS
4-color process

PAGES
three 4-panel brochures

SIZE
5" x 7" (13 cm x 18 cm)

PRINT RUN
10,000 of each of the four

COST PER UNIT
$0.25 U.S.

ILLUSTRATION **73**

>
FORKS & CORKS POSTER

THIS SPECIAL POSTER WAS DESIGNED TO promote a evening of fundraising at the Forks & Corks restaurant. It was inspired by works by Henri Toulouse-Lautrec, as well as the film *Moulin Rouge*.

[SOURCES OF INSPIRATION]

- **www.salon.com**
- *Metropolis* **magazine**
- *Wallpaper* **magazine**
- **Henri Toulouse-Lautrec, French artist (1864–1901)**
- *Moulin Rouge* **(2001) Baz Luhrmann, director**

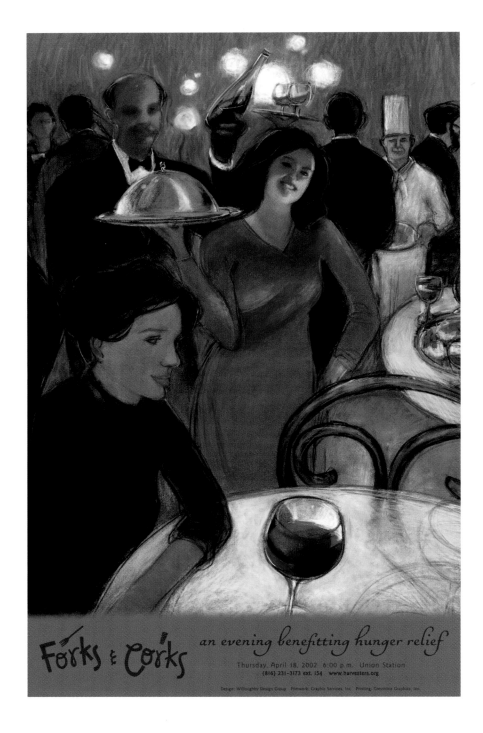

STUDIO
Willoughby Design Group

ART DIRECTOR
Ann Willoughby

DESIGNER
Hannah Stubblefield

ILLUSTRATOR
Ann Willoughby

CLIENT
Forks & Corks

SOFTWARE
Adobe Illustrator

COLORS
4-color process

SIZE
17$\frac{1}{2}$" x 27" (43 cm x 59 cm)

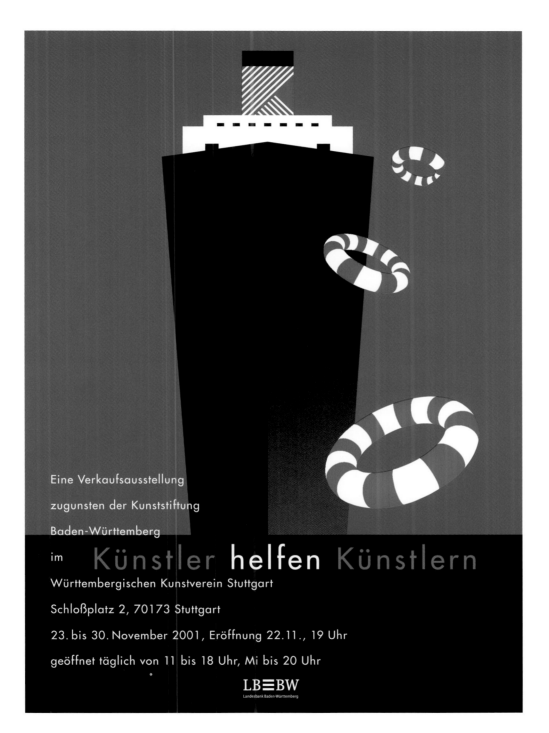

STUDIO
Art Direction + Design

ART DIRECTOR/DESIGNER
Michael Kimmerle

ILLUSTRATORS
Michael Kimmerle, Klaus Bossert

CLIENT
Kunststiftung Baden-Würtemberg

SOFTWARE
FreeHand, QuarkXPress

<

KÜNSTILER HELFEN KÜNSTLERN POSTER

MICHAEL KIMMERLE HAD BEEN SEARCHing for an idea that would illustrate someone or something helping someone else when it dawned on him: why not a ship and a lifesaver? Turning to the great steamship posters for inspiration, he found the look he wanted in an illustration of the *The Normandie* by French artist A.M. Cassandre circa 1935, promoting its route between Le Havre, Southampton and New York.

Kimmerle updated the look with clean, contemporary lines, integrated his client's red and white logo into the steam stack, and repeated the same palette in the three-dimensional lifesavers.

[SOURCE OF INSPIRATION]

■ **A.M. Cassandre, French commercial artist (1901–1981) (www.cassandre.fr)**

ILLUSTRATION 75

> BELLWETHER EXPLORATION ANNUAL REPORT

THIS ANNUAL REPORT TAKES ITS CUE from the dime store novels of the 1930s, 1940s, and 1950s. "The striking illustrations were created to draw people's attention to the newsstands to purchase the books," says Brandon Murphy, designer. "We loved the original work so much that we contacted the actual artists, estates, or collections to obtain usage rights."

To achieve the look of an aged dime novel, Murphy altered the type digitally as well as by hand. He even used a copy machine and tape to get the exact look he was after. Caslon Antique was used for the main body text and financial section, while a variety of faces were used in the headers and as decorative elements. These include: Cooper Black, Clarendon, Sport Script, Birch, Black Oak Polar, Ponderosa, Out West, Latin Wide, and Woodtype. In all, the result is fun and fanciful.

[SOURCES OF INSPIRATION]

■ Old book cover illustrations
■ Tom Lea, American painter (born 1907)

"I very much love bookstores and find it very difficult not to spend too much time or money."

— BRANDON MURPHY

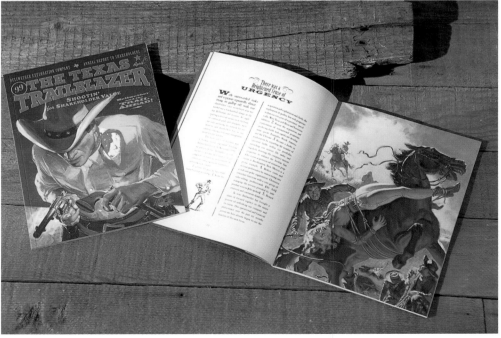

The color illustrations, which were reproduced from original pieces of art, are complemented by pen and ink drawings by El Paso, Texas illustrator Tom Lea, who originally did these illustrations in 1949 to accompany A Texas Cowboy *by Charles Siringo.*

STUDIO
Squires & Company

DESIGNER
Brandon Murphy

ILLUSTRATORS
Tom Lea, Mark Zingarelli, and various vintage illustrators from the 1930s and 1940s

CLIENT
Bellwether Exploration Company

SOFTWARE
Adobe Illustrator, QuarkXPress, Adobe Photoshop

PAPER
Monadnock Dulcet, French Duotone Butcher Off-White

COLORS
4-color process, plus one spot color and overall satin varnish

PAGES
60

SIZE
7¼" x 9¾" (18.5 cm x 50.5 cm)

PRINT RUN
15,000

COST PER UNIT
$4.75 U.S.

ILLUSTRATION **77**

>
ILLUSTRATION Nº2

WERBETEAM GMBH COMMISSIONED
this artwork to accompany an editorial
about discovering a new horizon in litera-
ture, the title of which was "Traveling to
New Borders: A Discussion About Modern
Literature." It was later used for a New
Year's greeting card as well.

Illustrator Rafe Christe took his inspira-
tion from various magazine and book
reviews, but also credits much of his inspi-
ration to Heinz Edelmann, who illustrated
the Beatles' *Yellow Submarine* film clip.
Christe studied illustration with Edelmann
for one year in a master class.

[**SOURCE OF INSPIRATION**]

■ **Heinz Edelmann, Czech artist, illustrator,**
 and graphic designer (born 1934)
■ ***Harper's Bazaar* magazine**
■ ***Rolling Stone* magazine**
■ ***Form* magazine (www.form.de)**
■ **ZKM Karlsruhe (Museum for Multimedia**
 Art, Karlsruhe, Germany)

STUDIO
Designhelden

CLIENT
Werbeteam GmbH

PAPER
250 g/m2

SIZE
8" x 5" (20 cm x 13 cm)

<

FLYING MUSIC

MISHA LENN CREATED THESE BLANK greeting cards with a simple illustration of two conductors and a fiddler, entitled *Flying Music*. According to Lenn, the look of this project was inpsired by Russian artist Marc Chagall's "art and illustrations and the way he influences viewers and creates moods."

[SOURCE OF INSPIRATION]

■ **Marc Chagall, Russian-French painter and stained glass artist (1887–1985)**

STUDIO
Misha Design Studio

ART DIRECTOR/ILLUSTRATOR
Misha Lenn

ILLUSTRATION **79**

>

25TH TELLURIDE FILM FESTIVAL POSTER

ROMANIAN-BORN AMERICAN ARTIST Saul Steinberg's sense of landscape influenced this film festival poster, according to Seymour Chwast. Steinberg, a cartoonist for *The New Yorker*, is perhaps best known for "A View of the World from 9th Avenue," which humorously depicts a dramatically condensed landscape as it might be seen by a New York native. The work debuted as *The New Yorker* cover March 29, 1976, and has been imitated on posters by scores of cities worldwide.

[SOURCE OF INSPIRATION]

■ **Saul Steinberg, Romanian-American illustrator (1914-1999)**

STUDIO
The Pushpin Group Inc.

ILLUSTRATOR
Seymour Chwast

COLORS
4-color process

STUDIO
Emma Wilson Design Company

DESIGNER/ILLUSTRATOR
Emma Wilson

SOFTWARE
FreeHand, Adobe Photoshop

PAPER
Hewlett Packard Premium
Ink Jet Paper 80 lb.

COLORS
4-color process

SIZE
11" x 17" (28 cm x 43 cm)

PRINT RUN
50

COST PER UNIT
$1.00 U.S.

In gratitude of mexican food,
I mean the Mexicans defeating the French in 1862,
we celebrate
the margarita, the tortilla chip,
carne adovada, cerveza,
and salsa, ay, ay!
your biscuits will burn and your head will spin

The fiesta begins at
four o'clock on Saturday
and ends with
a tequila sunrise

mi casa es su casa
9026 Meridian Place North, directions on mapquest or call us at 206/ 525-9533

CINCO DE MAYO INVITATION

"BEING NEW MEXICAN, CINCO DE MAYO was always a fabulous excuse to throw a party with food and cocktails," says Emma Wilson of this self-promotional invitation. "But having transplanted ourselves to Seattle, we thought that maybe the historical and cultural aspects of the holiday would be lost."

Wilson reviewed bullfighting and Mexican political propaganda posters to develop this design, which takes a contemporary, lighthearted approach to celebrating the Cinco de Mayo holiday. To get the look, Wilson scanned poor quality fonts from old type books and redrew them in FreeHand, ensuring that all their "lovely flaws and scars" remained intact.

The invitation is not only eye-catching but cost-effective; it was produced in quantity on Wilson's in-house ink-jet printer.

[S O U R C E S O F I N S P I R A T I O N]

- **Local theater posters**
- **Spanish bullfighting posters**
- *Contemporary Posters: Design and techniques* **by George F. Horn**
- *100 Years of Posters* **by Bevis Hillier**
- **Photographs of Mayan and Aztec art**
- **Milton Glaser and Seymour Chwast, American designers**

>

I OUGHT TO BE IN PICTURES POSTER

NORMAN ROCKWELL'S ILLUSTRATION of *A Girl at the Mirror* provided the inspiration for this poster promoting Neil Simon's *I Ought to Be in Pictures*. Salisbury chose Rockwell's 1940s-era illustrations because his work exemplifies all-American storytelling. The poster has been hand-lettered.

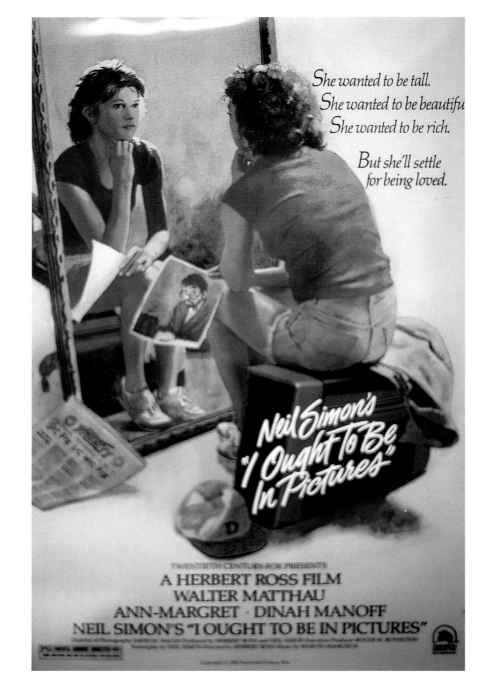

STUDIO
Mike Salisbury, LLC

ART DIRECTOR/DESIGNER
Mike Salisbury

ILLUSTRATOR
Gary Meyer

CLIENT
Twentieth Century Fox

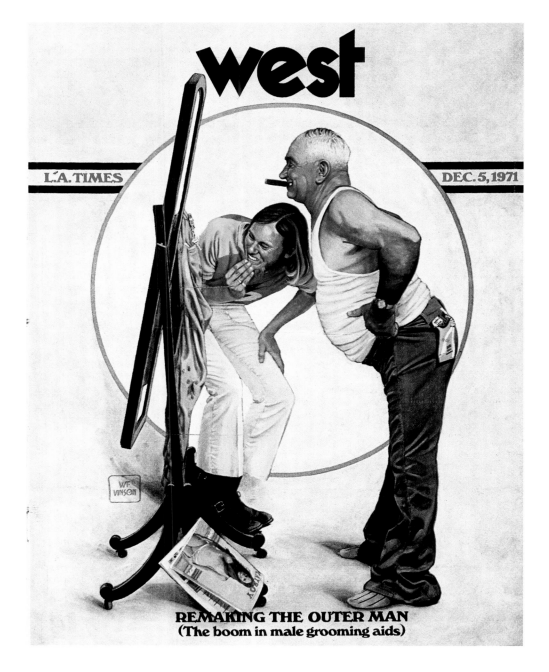

<

WEST MAGAZINE

STUDIO
Mike Salisbury, LLC

ART DIRECTOR/DESIGNER
Mike Salisbury

ILLUSTRATOR
W.T. Vinson

CLIENT
West magazine

PAPER
Newsprint

SIZE
Tabloid

RETAINED TO DEVELOP A COVER FOR
West magazine's story on "Remaking the
Outer Man," Mike Salisbury opted to give
a 1940s treatment to the 1970s story.
Using oil paints and a humorous, down-
to-earth style that borrows liberally from
Rockwell's work, Salisbury presents his
take on re-evaluating male appearance.

[SOURCE OF INSPIRATION]

■ **Norman Rockwell, American illustrator
(1914–1999)**

ILLUSTRATION **83**

BELLTOWN BROKER BASH INVITATION

"THIS PIECE WAS INSPIRED BY THAT ZANY illustrator Shag (Josh Agle) and clip art from the twenties, thirties, and forties," says Emma Wilson. "Shag's imagery always celebrates a cheesy tropical bar with tikis or swinging jet-setters. It's tongue-in-cheek art imitating life."

Amid all the fun is some serious design work, including hand-lettered copy for "The 1st Annual" and a customized deco font for "Belltown." The job was printed on a four-color digital press, which was the most effective route given the relatively small print quantity of three hundred pieces.

[SOURCES OF INSPIRATION]

- **Shag (Josh Agle), American artist (www.shag-art.com)**
- ***Supersonic Swingers* by Shag**
- ***1,001 Advertising Cuts from the Twenties and Thirties* compiled by Leslie Cabarga, Richard Greene and Marina Cruz**
- **Cartoons such as *The Jetsons, The Pink Panther,* and *Rocky and Bullwinkle***

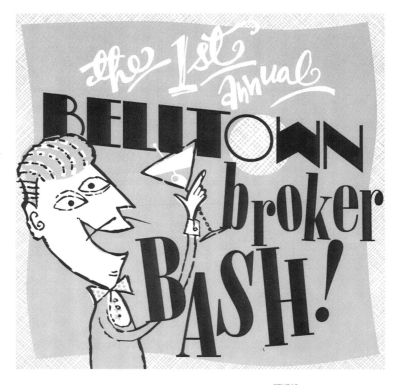

STUDIO
Emma Wilson Design Company

DESIGNER/ILLUSTRATOR
Emma Wilson

CLIENT
Intracorp

SOFTWARE
Adobe Photoshop, FreeHand

PAPER
#2 cover sheet (stocked at printer)

COLORS
4-color process

SIZE
5$^{1}/_{2}$" x 5$^{1}/_{2}$" (14 cm x 14 cm)

PRINT RUN
300

COST PER UNIT
$0.75 U.S.

YOU'RE INVITED!

As a broker with *panache and urban savvy,*

we'd like to celebrate your success

- past, present and future -

at our **FIRST ANNUAL BROKER BASH!**

Please join us for **COCKTAILS, MUSIC**

and **scrumptious FOOD** from Kaspars Catering.

SEPT. 19TH *Wednesday*

Please join us at:
**The Vine Building Sales Center
2500 First Avenue**
from 5 o'clock to 7 o'clock

Please RSVP by calling
(206) 832-0041 *or email us*
sales@thevinebuilding.com

The
BOSTON
POPS
2001
HOLIDAY
SOUVENIR
MAGAZINE

BOSTON
POPS

STUDIO
Misha Design Studio

ART DIRECTOR/DESIGNER
Susan Stehfess, Leon Poindexter
(magazine contents)

ILLUSTRATOR
Misha Lenn (original watercolor)

CLIENT
Boston Pops

BOSTON SYMPHONY ORCHESTRA
BOSTON POPS TANGLEWOOD
BOSTON SYMPHONY ORCHESTRA

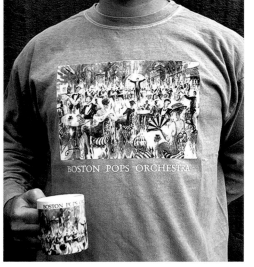

<

A NIGHT AT THE POPS

WHEN THE BOSTON POPS NEEDED ART-
work for its 2001 Holiday Souvenir
Magazine, it called upon Misha Lenn to
create an original watercolor that would
generate excitement for its holiday
season. Lenn drew his inspiration from
famed illustrator Henri Toulouse-Lautrec
to create *A Night At the Pops*. Toulouse-
Lautrec "was an illustrator of life and
people," says Lenn. "He invented the
form of posters for theater and show
presentations."

Lenn's artwork was integrated into the
souvenir program and placed on mugs
and t-shirts as well.

[SOURCE OF INSPIRATION]

- **Henri Toulouse-Lautrec, French artist
 (1864–1901)**
- **www.interesting.com/stuff/lautrec/**
- **www.sandiegomuseum.org/lautrec/**

ILLUSTRATION 85

>
BRAINSTORM JOURNAL

WHILE THIS JOURNAL WAS CONCEIVED
by Belyea, the real drive for the design
development came from an earlier collab-
oration with Rep Art, an agency which
represents many Canadian illustrators.
Belyea had the idea to commission twen-
ty original pieces of artwork to illustrate
twenty contemporary quotes on creativi-
ty. Each artist received the list of twenty
quotes and was asked to designate a first,
second, and third choice of a quote they
wanted to illustrate. "When the choices
were reviewed, not one artist had the
same first pick as another," says Patricia
Belyea. "So [each illustrator] was truly
inspired by their artistic responses."

The illustration pages are French-folded; the reverse of each page features an illustrative response made of letterforms of a key word taken from the quote. The design is colored and patterned to emulate the original illustration. "Extra proofing was required to match the colors of the typographic illustrations to the original artwork," says Belyea. "Once the first round of proofs was reviewed and marked-up, the pre-press team at Color Graphics adjusted specific colors and re-proofed."

ILLUSTRATION **87**

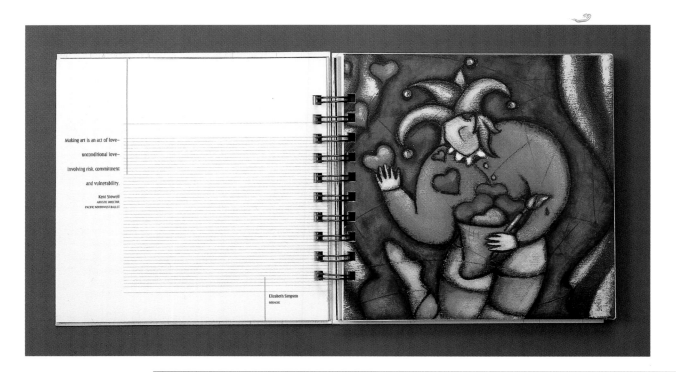

"Every first Thursday of the month in Seattle there is an Art Walk. All the galleries stay open late, new shows open, and the streets are crowded with folks going from art show to art show. We are inspired by the new and up-and-coming artists and by the abundance of nouvelle art that is full of spirit."

— PATRICIA BELYEA

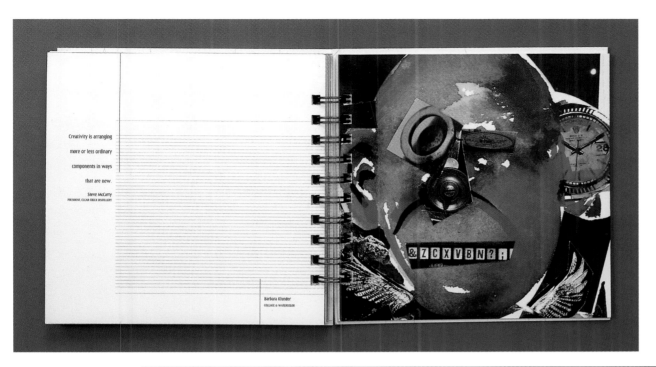

STUDIO
Belyea

CREATIVE DIRECTOR
Patricia Belyea

DESIGNERS
Anne Dougherty, Ron Lars
Hansen, Naomi Murphy,
Kelli Lewis

ILLUSTRATORS
Charles Bell, Jeff Burgess,
Elizabeth Simpson, James
Lorincz, Mark Heine, John
Bolesky, Steve Hepburn,
Michael McKinnell, Gavin
Orpen, Lorne Carnes, Glenn
Mielke, Kelly Brooks, Kathryn
Shoemaker, Michael Knox, Bar-
bara Klunder, Sharon Smith

PHOTOGRAPHERS
Storme, Greg Eligh, Tony Red-
path, Lesley Burke

SOFTWARE
QuarkXPress

PAPER
cover: Curious Sensation Bright
White Cover 100 lb.; fly sheet:
Curious Canson Satin Text 48 lb.;
journal pages: Curious Sensation
Bright White Cover 63 lb.; illustra-
tion pages: Utopia Premium Blue
White Silk Text 90 lb.

PAGES
96

COLORS
4-color process plus 4 spot colors

PRINT RUN
1500

ILLUSTRATION **89**

> ## EPHEMERA PHILATELICA STAMP
> ## ALBUM AND BOX

TO PROMOTE ITS SPECIALTY PRINTING processes, Dickson's, Inc. retained Michael Osborne Design to create a one-of-a-kind promotion. Twenty-six designers from the AIGA San Francisco chapter participated. Each was assigned a different letter of the alphabet and was told what that letter represented in the historical context of stamp collecting. With that direction, they were given free reign to create individual stamps, drawing inspiration from the world of fine art and illustration—particularly old postal imagery and other vintage advertising.

MOD assembled artwork from all the designers into a full sheet of stamps. In addition, they placed a stamp on each page of a luxurious album that was custom-created for this project.

[SOURCES OF INSPIRATION]

- **Postal imagery**
- **Vintage advertising**

STUDIO
MOD/Michael Osborne Design

ART DIRECTOR
Michael Osborne

DESIGNER
Paul Kagiwada

CLIENT
Dickson's, Inc.

PAPER
Gmund Havanna, Champion
All-Purpose Litho

PAGES
40

SIZE
8¼" x 8¼" (21 cm x 21 cm);
box: 12½" x 9 (32 cm x 23 cm)

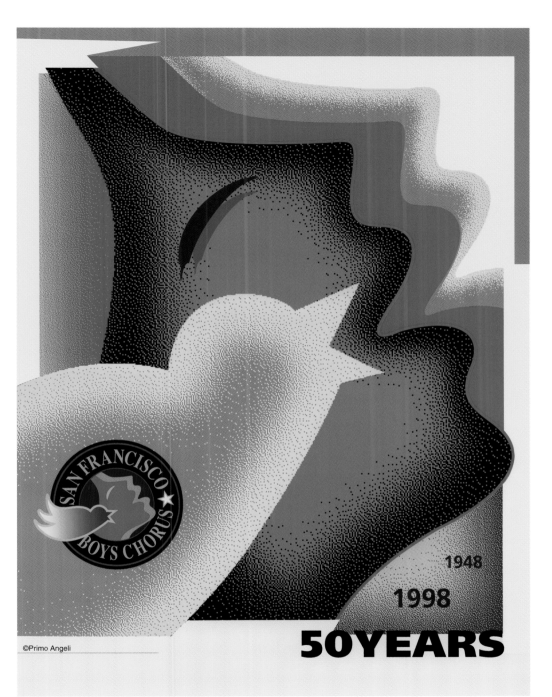

STUDIO
Primo Designs

ART DIRECTOR/DESIGNER
Primo Angeli

ILLUSTRATORS
Primo Angeli, Chotima
Buranabanphot

CLIENT
San Francisco Boys Chorus

SOFTWARE
Adobe Photoshop, Adobe
Illustrator

PAPER
Uncoated, chemical-free
cover stock

COLORS
8 (screen process)

PRINT RUN
500

<

SAN FRANCISCO BOYS CHORUS POSTER

PRIMO ANGELI USED THE COMPUTER'S
airbrush effect to reflect "the tonal warmth
and charm that always impressed me in
the work of A.M. Cassandre," says Angeli,
citing the works of the famed poster artist.

[SOURCE OF INSPIRATION]

■ **A.M. Cassandre, French commercial
artist (1901–1981)**

ILLUSTRATION 91

YEAH, YEAH, YEAH…BROCHURE

ADVERTISING AND CARTOON HUMOR of the 1950s provided the inspiration for this brochure promoting Hanes Comfort-T. The main character yawns his way throughout the brochure, so bored is he with the typical sales pitches for t-shirts…that is, until he hears the price. The brochure, designed in a lively palette of cartoon colors, comes to life with a large pop-up, which—like the product's price—is hard to yawn at.

"[Cartoon humor] was chosen as an entertaining way to represent the screenprinters' sometimes jaded approached to hearing about new product information in the t-shirt industry."

— HAYES HENDERSON

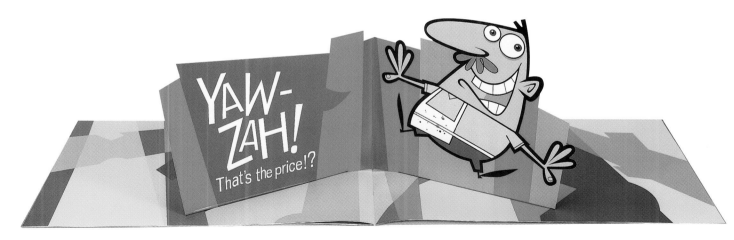

STUDIO
Henderson Bromstead Art

ART DIRECTOR
Hayes Henderson

DESIGNER
Christine Celic

ILLUSTRATOR
Chip Wass

CLIENT
Hanes Comfort-T

SOFTWARE
Adobe Illustrator

PAGES
16

SIZE
12$\frac{1}{2}$" x 9$\frac{1}{2}$" (32 cm x 24 cm)

PRINT RUN
20,000

ILLUSTRATION **93**

> THE MOHAWK TRAIL

THE LOOK—OR "ATTITUDE" AS SEAN Adams describes it— for this poster came from the style of illustrations on matchbook covers commonly found in casinos between 1950 and 1970. AdamsMorioka employed this kitschy style to promote Mohawk papers. To keep the type consistent with the style of the artwork, designers based the logo font on News Gothic Bold Condensed, but redrew it in Adobe Illustrator.

"The concept of the combination of disparate imagery was inspired by paintings by James Rosenquist and his idea of multiple images and narrative forming meaning," says Sean Adams.

[SOURCES OF INSPIRATION]

- **James Rosenquist, American artist (born 1933)**
- *James Rosenquist: The Early Pictures, 1961–1964* **by Judith Goldman**
- **Matchbook illustrations**

STUDIO
AdamsMorioka

ART DIRECTOR
Sean Adams

PHOTOGRAPHERS
Don Dondero, Philip Hyde

CLIENT
Mohawk Trails

SOFTWARE
Adobe Photoshop, Adobe Illustrator

PAPER
Mohawk Superfine Cover 80 lb.

COLORS
4-color process plus 2 PMS colors and dull varnish

SIZE
24" x 36" (61 cm x 91 cm)

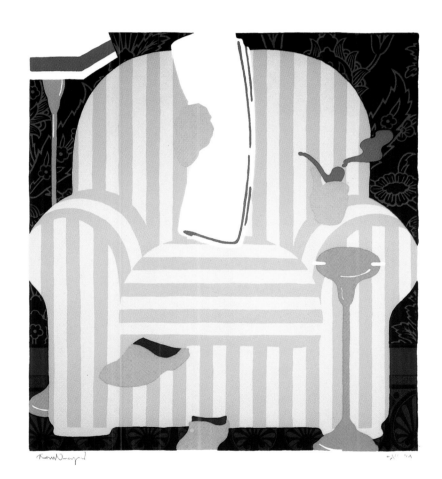

STUDIO
The Pushpin Group Inc.

ART DIRECTOR
Ruth Ansel

ILLUSTRATOR
Seymour Chwast

CLIENT
New York Times Magazine

COLORS
4-color process

<

WHERE'S FATHER?

LUDWIG HOHLWEIN, THE GERMAN
minimalist poster designer, provided the
inspiration for this cover of the *New York
Times Magazine* on the theme of Mother's
Day. Hohlwein trained as an architect
before he got into poster design in 1906.
According to Seymour Chwast, high tonal
contrasts and a network of interlocking
shapes make his work recognizable.
During World War I, Hohlwein was
employed by the German government
to produce propaganda posters.

[SOURCE OF INSPIRATION]

▪ **Ludwig Hohlwein, German artist
(1874–1949)**

ILLUSTRATION **95**

>

"CHARLES CHICKENS" CONFERENCE BOOK AND PRESENTER BOX

TO PROMOTE A CONFERENCE IN England's Lake District, Cross Colours created a miniature book enclosed in a presentation box with a literary theme. Charles Dickens became "Charles Chickens" and all the conference elements parodied the famous author and illustration styles of past eras. "My intention was to parody the great English author with images and typography drawing on Dickensonian literature, with visual puns and irreverent overtures reflecting the upbeat brand," says Joanina Pastoll, one of the creative directors on the project.

[SOURCE OF INSPIRATION]

■ **Charles Dickens, English novelist (1812–1870)**

STUDIO
Cross Colours

CREATIVE DIRECTORS
Joanina Pastoll, Janine Rech

DESIGNER/ILLUSTRATOR
Scott Harrisson

CLIENT
Nando's

PAPER STOCK
Hanno Matt

COLORS
4-color process

PRINT RUN
40

FESTIVAL OF BOSTON '97

STUDIO
Misha Design Studio

ILLUSTRATOR
Misha Lenn

CLIENT
Arts Festival of Boston

<
ART FESTIVAL OF BOSTON LOGO

MISHA LENN DREW HIS INSPIRATION FOR
the Arts Festival of Boston's logo from the
exquisite and elegant covers of *The New
Yorker* as created by illustrator Rea Irvin.

[SOURCES OF INSPIRATION]

- **Metropolitan Museum of Art, New York**
 (www.metmuseum.org)
- **Museum of Fine Arts, Boston**
 (www.mfa.org)
- **The Art Institute of Chicago**
 (www.artic.edu/aic)
- **The State Hermitage Museum, St.**
 Petersburg, Russia (www.hermitage-
 museum.org)
- **Rea Irvin, illustrator for *The New Yorker***

ILLUSTRATION **97**

>

AD CLUB OF SILICON VALLEY ADDY EVENT COLLATERAL

"THE CHALLENGE FOR PACIFICO WAS TO package the concept that we as creatives are challenged every day to create magic in spite of looming deadlines, small budgets and difficult clients. 'Pulling rabbits out our hat' is a common occurrence in advertising and design," explains Boyd Tveit, who found inspiration in old magic show and vaudeville poster illustrations.

The program consisted of a direct mail piece that consisted of a small white cloth bag with the event icon rubber-stamped on it. Enclosed was a save-the-date card, reservation card, and a card recognizing the pro bono vendors for the event. Three weeks later the poster was sent out in a white mail tube with the rules, categories and entry form on the back.

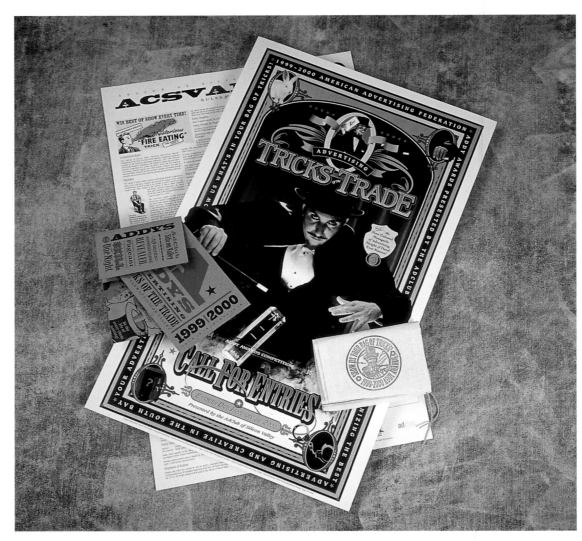

ART DIRECTOR
Boyd Tveit

DESIGNER
Phillip Mowery

COPYWRITER
Rich Greenwood

PHOTOGRAPHER
Robert Miller

ILLUSTRATOR
Boyd Tveit

CLIENT
Ad Club of Silicon Valley

SOFTWARE
QuarkXpress, Adobe Illustrator and Adobe Photoshop

COLORS
4-color process both sides, plus one metallic match color on front

PRINT RUN
3000

COST PER UNIT
Printing and design donated

TYPEFACES
Caxton, Juniper, Palatino, Cochin, Birch and Glypha

ART DIRECTOR
Boyd Tveit

DESIGNER
Phillip Mowery

COPYWRITER
Scott Murray

ILLUSTRATOR
Boyd Tveit

CLIENT
Ad Club of Silicon Valley

SOFTWARE
QuarkXpress, Adobe Illustrator
and Adobe Photoshop

PAPER
Fox River Starwhite Vicksburg
Tiarra smooth 80# text

COLORS
2 match

SIZE
11" x 17"

PRINT RUN
2000

TYPEFACES
Folio, Citizen

<

AD CLUB OF SILICON VALLEY NEWSLETTER

BOYD TVEIT EXPLAINS, "TECHNOLOGY advertising and design often presents itself with sophisticated photography...We decided to approach this technology cover story about being connected by using an illustrative style that affirms the human side of the story: technology serves the needs of people. The loose, spontaneous execution of the layout supports the notion of the human element in technology. The story about being connected is counterbalanced by the loose design and primitive illustrative style."

[SOURCES OF INSPIRATION]

- **Stuart Davis, American painter (1892–1964)**
- **Jasper Johns, American abstract artist (born 1930)**
- **Sandro Chia, American artist, (born 1946)**

ILLUSTRATION **99**

[SECTION]

3

Online resources for inspiration from film, photography, and cinematography:

Academy of Motion Picture Arts and Sciences (www.oscars.org)

All Movie Guide (www.allmovie.com)

American Movie Classics (www.amctv.com)

Internet Movie Database (www.imdb.com)

Movie Trailers Database (www.comingsoon.com)

OR VISIT THESE ONLINE MUSEUMS…
California Museum of Photography, Riverside, California (www.cmp1.ucr.edu)

George Eastman International Museum of Photography and Film, New York (www.eastman.org)

The Museum of Modern Art (MoMA), New York (www.moma.org)

The Museum of Television & Radio, New York (www.mtr.org)

inspired by [FILM, PHOTOGRAPHY & CINEMATOGRAPHY]

From the obscure independent film to the blockbuster, we all have favorite movies, but the ones that provide the most inspiration are those that touch us, thrill us, and send us out of the theater talking. The films that spark our imagination are the innovative ones whose artistic designs pushed the envelope for their time—the cinematography of *Gone With the Wind*, the title sequences of *Psycho*, *Vertigo*, and *The Terminator*, or even Robert T. McCall's poster design for *2001: A Space Odyssey*. Designers revel in inspiration found in everything from poster, costume and set design to title sequences.

Famous photographers are also inspiring to those designers profiled here—most notably George Hurrell, who photographed actors and actresses of the 1930s with such flair that he is credited with single-handedly turning them into the glamorous stars of Hollywood's golden era.

mike SALISBURY

> > >

"Anything and everything," says Mike Salisbury, Salisbury Communications, LLC. "I've even picked up the Yellow Pages. I was stuck in a hotel room and couldn't think of anything for a logo, so I picked up the Yellow Pages and started looking for something that would be an inspiration. Somehow something always comes to my hand that works for what I need it to do. Other times, there is just something that would be appropriate that you remember from the past that was really cool and would work."

Salisbury, renowned for branding and marketing design work that has defined American pop culture, is one of the creative forces behind movie campaigns like *Jurassic Park* (1993), *Raiders of the Lost Ark* (1981), Tim Burton's *Planet of the Apes* (2001) and many more. He's branded products, too, including Levi's 501 jeans, and developed and redesigned publications such as *Rolling Stone*, *Playboy*, *Hot Rod*, and *Surfer*. He began creating when he was fifteen years old and today, his work

can be found in the permanent collections of the Smithsonian, the Library of Congress, and the Museum of Modern Art.

Frequently, he is invited to speak at functions around the globe where students seek his advice and ideas for sources of inspiration. "The way I work, particularly in movies and records and even for more traditional clients, is to first look at the assignment and do things top of mind…things you can do spontaneously and randomly. Put down all those ideas. Then, read the script, listen to the music or go through the research. Finally, come up with ideas that are inspired by all those things. But first, do things top of mind that might just happen to work—free association."

Salisbury also suggests designers be open to new ideas, and he takes his own advice. "Well, I've tried a lot of stuff. I was an illustrator, I take pictures for magazines, I tried painting. When you have a hand in that stuff you get a better feeling for what it is all about," he says. "You have to pay

attention to it and keep an open mind. It is like Pollock. A lot of people think that Jackson Pollock is splatter stuff, but it really isn't. He had to design those paintings because they have an almost perfect balance between negative and positive space.

"A lot of it is not just me educating myself and discovering things; it is listening to what other people say and what they like. I didn't know much about abstract expressionism until a guy I worked with at *Playboy* turned me on to it."

Salisbury finds his inspiration wherever he can get it, seeking out pop shrines like Graceland and the James Dean Memorial Gallery, as well as fine art museums when he's between flights and out of town meetings. "I don't usually have a problem concentrating and coming up with ideas. It's fun. I live my work. So maybe that's where all the ideas come from. I don't separate working from the rest of life. I can just be thinking about it all the time and then I'll see something—because there is so much stuff in the environment that will work."

STUDIO
Mike Salisbury, LLC

**ART DIRECTOR/DESIGNER/
PHOTOGRAPHER**
Mike Salisbury

CLIENT
Harry's Bar

COLORS
4-color process

PRINT RUN
100,000

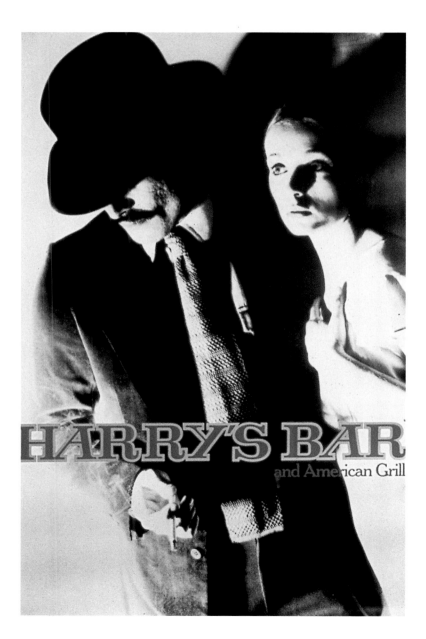

<

HARRY'S BAR POSTER

MIKE SALISBURY WAS TRYING TO IMAGINE a period, film-noir look for a poster promoting Harry's Bar, and the works of Hollywood photographer George Hurrell had just the look he was seeking. Turning from art to photography at age 25, Hurrell changed the way film studios of the 1930s and 1940s presented their stars, and influenced the movie-going public's perceptions of actors and actresses forever after. His highly stylized, sensual studio portraits of big MGM stars such as Norma Shearer, Joan Crawford and Jean Harlow are among his most recognizable works.

[SOURCE OF INSPIRATION]

■ **George Hurrell, Hollywood
photographer (1904–1992)
(www.hurrellphotography.com)**

>
THE ADAMSMORIOKA STORY

"THERE IS A SEQUENCE IN THE MOVIE *Inside Daisy Clover* with Natalie Wood, where a faux documentary of Daisy's life is shown to the unsuspecting public," says Sean Adams. "We liked the idea of taking bits of truth and remaking the 'AdamsMorioka Story.'"

[S O U R C E O F I N S P I R A T I O N]

■ *Inside Daisy Clover* (1965)
 Robert Mulligan, director

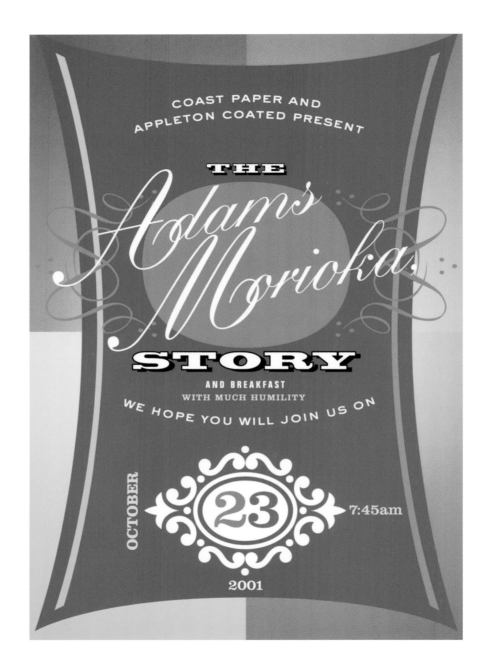

STUDIO
AdamsMorioka, Inc.

ART DIRECTOR
Sean Adams

CLIENT
Appleton Paper, Coast Paper

SOFTWARE
Adobe Photoshop, Adobe Illustrator, Adobe PageMaker

PAPER
Utopia One X, Xtra Bright Silk Text 100 lb.

COLORS
4-color process

PAGES
16

SIZE
5" x 7" (13 cm x 18 cm)

The "story" comes as a breakfast invitation in the form of a booklet. Inside, snippets from the lives of Sean Adams and Noreen Morioka—not to mention their ancestral histories—are narrated in one-sentence captions that playfully point to the photos' features. We only wish everyone who decided to present their company history did so in such an entertaining fashion.

> GIANT

INSPIRATION SPURS ON INSPIRATION, AS seen in Mike Salisbury's work. Initially, he turned to the James Dean–Elizabeth Taylor film *Giant* for inspiration when he wanted to create a visual metaphor for women's jeans cut like a man's. The campaign was so eye-catching and successful that succeeding clients wanted the same idea executed in their campaigns.

Salisbury utilized the same theme with slight modifications, all saluting the 1956 film. Here, his work is seen with the original project for Levi's 501 women's jeans; then later in a poster for the Brad Pitt film, *Legends of the Fall* (1994); and Whoopi Goldberg's *Fatal Beauty* (1987).

[SOURCE OF INSPIRATION]

■ *Giant* (1956) **George Stevens, director**

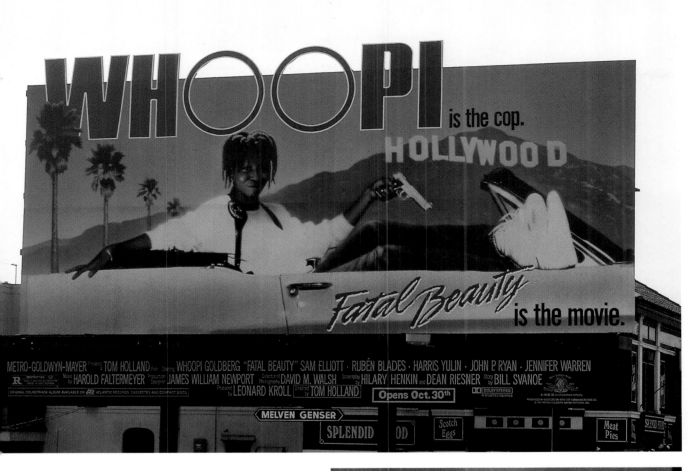

STUDIO
Mike Salisbury, LLC

ART DIRECTOR/DESIGNER
Mike Salisbury

ILLUSTRATORS
Joe Heiner, Terry Lamb, Pat Linge,
Vilmos Zigmond Juhász

CLIENTS
MGM Studios, Saturday Review,
Sony Pictures, Levi's

SOFTWARE
Adobe Photoshop, Adobe
Illustrator, QuarkXPress

COLOR
4-color process

THE ACADEMY AWARDS OF DESIGN POSTER

THIS POSTER, CREATED FOR AN ANNUAL report show hosted by paper distributor Xpedx, hearkens back to the black-and-white films of the 1930s and, specifically, the posters that promoted Hollywood's Golden Era. The poster gets its authentic look from the printing techniques. A silver-tinted dull varnish over double hits of a high-gloss black and a retro blue-green metallic give the poster a "silver screen feel," according to Gregg Palazzolo.

Palazzolo used vertically scaled type-faces commonly associated with the era—Empire and Helvetica—with only minor alterations to specific characters.

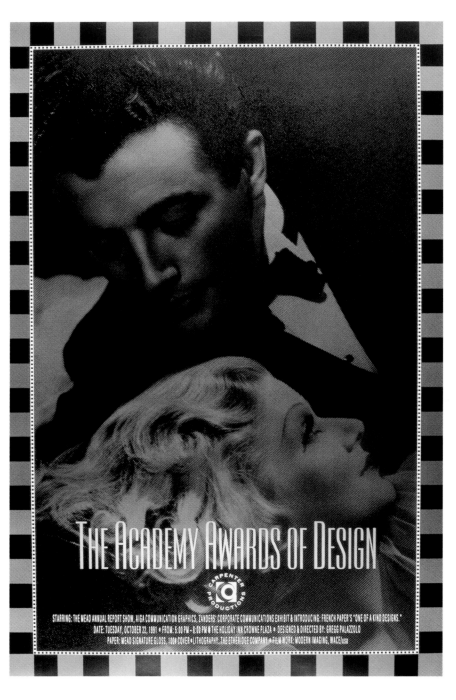

STUDIO
Palazzolo Design Studio

ART DIRECTOR/DESIGNER
Gregg Palazzolo

CLIENT
Xpedx Carpenter Group

SOFTWARE
Adobe Illustrator, Adobe Photoshop

PAPER
Mead Gloss Cover 60 lb.

COLORS
2 hits of black, 1 hit of metallic, 1 hit of silver-tinted dull varnish

SIZE
24" x 38" (61 cm x 97 cm)

PRINT RUN
1000

ORCA CORPORATE IDENTITY BROCHURE

ORCA, ONE OF GERMANY'S LEADING companies for virtual industrial design, has a futuristic design—largely provided by a type treatment that mimics the opening credits of the film *Total Recall*, and a color palette inspired by cybernetic films such as *RoboCop* and *Terminator*. Shades of green on a black background create a strong scientific image. "It was obvious because of the company's unusual science fictional name, which led us to the idea of creating a cinematographic feel," says Marçel Robbers, art director, designer, and illustrator on the project.

"Most important for the 'Orcanic' type-set was that the letters had to appear futuristic and technical," adds Robbers. "This was eventually realized by cutting the letters in horizontal lines, giving the feeling of something we call 'scan-optic.'"

[SOURCES OF INSPIRATION]

- *The Terminator* (1984) James Cameron, director
- *RoboCop* (1987) Paul Verhoeven, director
- *Total Recall* (1990) Paul Verhoeven, director

STUDIO
Braue Branding
& Corporate Design

ART DIRECTOR/DESIGNER/ ILLUSTRATOR
Marçel Robbers

CLIENT
ORCA Engineering GmbH

SOFTWARE
Adobe Photoshop, Adobe Illustrator, QuarkXPress, Fontographer

PAPER
Profistar 350 gr.

COLORS
2 match colors

SIZE
12" x 8¹/₄" (29.7 cm x 21 cm)

PRINT RUN
1000

"Everyone working at Braue Branding & Corporate Design is an avid movie fan. After having seen almost every movie made, drawing inspiration from the film industry has always been a given, whether it is a certain directional style or a well-designed credit sequence."

— MARCEL ROBBERS

>
BIGFRUIT IS REAL POSTER

ONE CAN'T LOOK AT THIS POSTER WITH-
out remembering the shaky hand-held
16 mm Kodak movie shot of Bigfoot by
Roger Patterson and Bob Gimlin in 1967.
Repeated viewings of that film—not
knowing if Bigfoot was real, but hoping
that he was—created an indelible mem-
ory in nine-year-old Dan Stewart's mind.

Today, Dan's all grown up, but he
summoned that memory and put it to
work communicating the "intense fruit
flavors, real and untamed" of Dole® soft
serve. "We wanted to capture the excite-
ment of 'BigFruit is Real' and we wanted
our nine-year-old brains back," says
Stewart.

You see the fleeting image of Bigfoot
and wonder, "Is that what I think it is in his
hand?" Upon closer inspection, it is: Dole®
soft serve in a cone. A custom-made prop
of Bigfoot's hand was made expressly for
this photo shoot and the "untamed"
theme of the poster is carried through to
the hand-painted headline.

[SOURCES OF INSPIRATION]

■ **16mm film**
■ **www.barewalls.com**

STUDIO
The Marlin Company

ART DIRECTOR
Dan Stewart

COPYWRITER
Judith Garson

PHOTOGRAPHERS
Jon Bruton (Bruton/Stoube
Studios)

BIG FOOT IMAGE
Roger Patterson, Bob Gimlin

CLIENT
Precision Foods, Inc.

SOFTWARE
Adobe Illustrator, Adobe
Photoshop

COLORS
4-color process

SIZE
18" x 24" (46 cm x 61 cm)

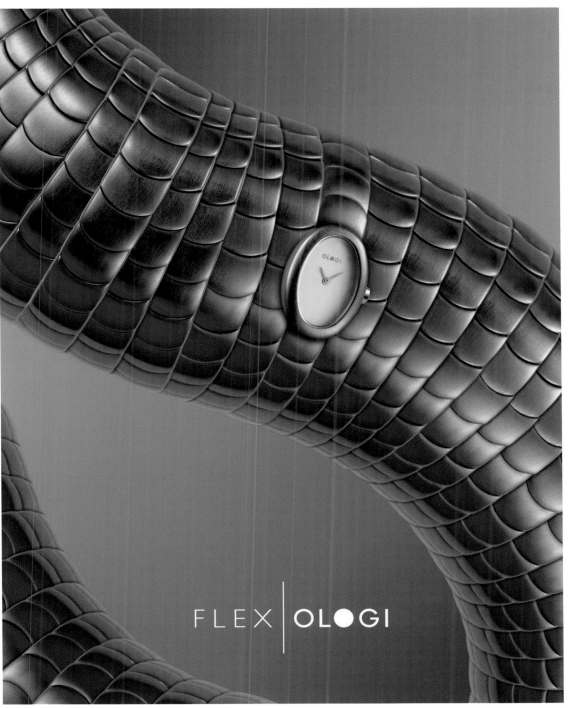

FLEX|OL●GI

OLOGI PACKAGING AND POSTER

GOLDEN STATE INTERNATIONAL IS A licensee for several major watch brands, but when they decided to introduce a brand of their own, they came to Turner Duckworth for help creating a unique identity. Because the new watch brand combined the latest in watchmaking technology with a minimalist design, Turner Duckworth sought inspiration from science-fiction films when they set out to design the product's packaging and promotional poster. "Sci-fi films have presented us with versions of the future, therefore it made sense to take cues from sci-fi films to create a futuristic watch brand," says David Turner.

STUDIO
Turner Duckworth

ART DIRECTORS
David Turner, Bruce Duckworth

DESIGNER
David Turner

PHOTOGRAPHER
Michael Lamotte

CLIENT
Golden State International

SOFTWARE
Adobe Photoshop, FreeHand

> FOSSIL FALL LOOKBOOK 2001

FOSSIL'S FALL 2001 LOOKBOOK FEATURES
an interesting twist on photography:
using different types of exposures and
film to add an element of visual interest to
each scene—the same style of photogra-
phy used in the film *Traffic*, which was
directed by Steven Soderbergh.

[S O U R C E S O F I N S P I R A T I O N]

- *Traffic* **(2000) Steven Soderbergh,
 director**
- **www.medianspirations.com**
- *American Roadtrip* **by Jeff Brouw**
- **Kimbell Museum, Fort Worth, Texas
 (www.kimbellart.org)**

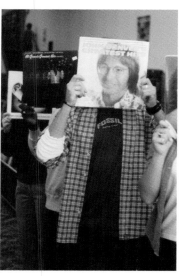

STUDIO
Fossil

ART DIRECTORS
Stephen Zhang, Tim Hale

DESIGNER
Marty Christiansen

PHOTOGRAPHER
Russ Aman

CLIENT
Fossil

SOFTWARE
Adobe InDesign, Adobe
Photoshop

PAPER
Navajo text 80 lb.

COLORS
4-color process

PAGES
32

SIZE
8" x 12" (20 cm x 30 cm)

PRINT RUN
2000

COST PER UNIT
$3.00 U.S.

"The scenes from Traffic shot in Mexico had a warm, grainy documentary feel. The shots in Washington DC were cool and crisp. We chose to push the film and use an amber filter to achieve that same effect as the scenes shot in Mexico," says Marty Christiansen, Fossil designer.

>

TARGET MARGIN THEATER 2001 GALA INVITATION

"WHEN CHARGED WITH CREATING A benefit invitation that both celebrated the past while looking forward to the future for a theater company that is constantly reinterpreting the past, we turned to the naïve futurism of 1950s science-fiction and mental-health films. The title and faux scientific charts could easily have been found in a classroom film with a warbly soundtrack," says Noah Scalin, art director on the project.

The invitation's ominous headline, "What does the future hold?" launches a theme that runs throughout the piece, and the inside copy states that "the future of Target Margin Theater is in your hands!"

"Specific inspiration was found in the dramatic backlighting in the Criswell portion of Ed Wood's masterpiece, *Plan 9 From Outer Space*, considered the worst film of all time by some," says Scalin. "A portion of [Criswell's] speech is even quoted inside."

[SOURCE OF INSPIRATION]

■ *Plan 9 From Outer Space* (1958) Ed Wood, director

"We are all interested in the future, for that is where you and I are going to spend the rest of our lives."

— CRISWELL, *PLAN 9 FROM OUTER SPACE*

STUDIO
ALR Design

ART DIRECTOR/DESIGNER/ ILLUSTRATOR
Noah Scalin

CLIENT
Target Margin Theater

SOFTWARE
QuarkXPress, Adobe Illustrator

COLORS
1-color

PAGES
10 panels

SIZE
4" x 5³⁄₈" (10 cm x 13.5 cm)
folded, 20" x 5³⁄₈" (51 cm x 13.5 cm) open

PRINT RUN
6000

COST PER UNIT
Less than $1.00 U.S.

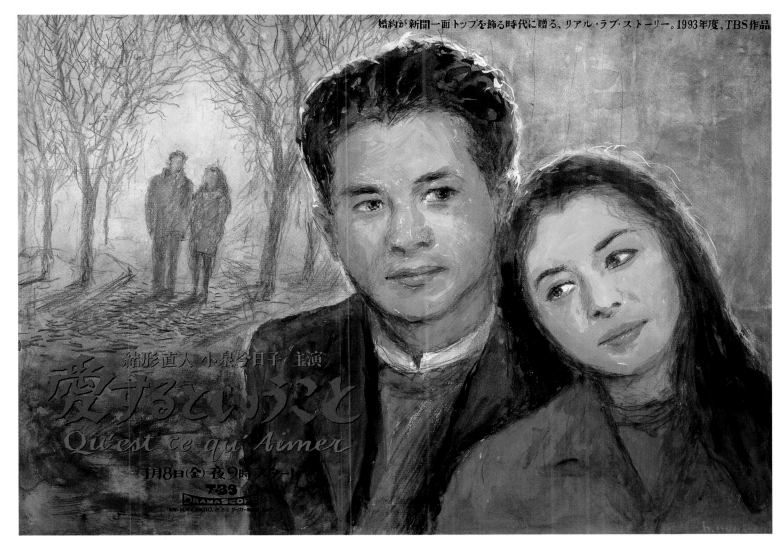

<

TBS TV DRAMA "QU'EST CE-QU' AIMER" POSTER

OLD POSTERS FOR EUROPEAN FILMS shown in Japan inspired this poster for a television drama appearing on Japanese stations. "In Japan, we didn't use photos on cinema posters in old times. Almost all posters used illustrations," says Kenzo Izutani, art director. The late Hisamitsu Noguchi, who is famous for his life-like illustrations, created this one. "Some of his artworks are my favorite sources of inspiration," adds Izutani.

STUDIO
Kenzo Izutani Office Corporation

ART DIRECTOR
Kenzo Izutani

DESIGNERS
Kenzo Izutani, Aki Hirai

ILLUSTRATOR
Hisamitsu Noguchi

CLIENT
Tokyo Broadcasting Systems (TBS)

PAPER STOCK
New Age 135 kg

COLORS
4-color process

PRINT RUN
200

>

COMET PRODUCT CATALOG & INVITATION CARDS

TO COMMEMORATE THE Y2K CELEBRA-
tion, Braue Branding & Corporate Design
opted to create a mood reminiscent of a
Hollywood premiere. Designers replaced
the letters in the famed Hollywood sign
with their client's name, Feuerwerk, the
German word for fireworks. "The headline,
'It's showtime,' generated the feeling of a
promotional movie poster. The claim
resurfaced on the product exhibition's
invitation cards. The ignited fuse repre-
sents time running out for the millenni-
um, and was evidently inspired by the
Mission: Impossible feature film and TV
series," says Kai Braue.

"One of our favorite movies, *Last
Action Hero,* has to be credited for the
exhibition's admission tickets," adds Braue,
noting that the tickets were letterpressed
to look more similar to actual movie
theater tickets. "Finally, 'The End' on the
product catalog's back cover rounded out
our concept of creating the feeling of a
blockbuster movie premiere."

[SOURCES OF INSPIRATION]

■ *Last Action Hero* (1993) John McTiernan, director
■ *Mission: Impossible* (1996) Brian dePalma, director

STUDIO
Braue Branding
& Corporate Design

ART DIRECTORS
Kai Braue, Marçel Robbers

DESIGNERS
Marçel Robbers, Raimund Fohs

ILLUSTRATOR
Marçel Robbers

CLIENT
Comet Pyrotechnik GmbH

SOFTWARE
Adobe Photoshop, Adobe
Illustrator, QuarkXPress,
Adobe Dimensions

COLORS
4-color process

PAGES
60

SIZE
11³/₄" x 8¹/₄" (29.7 cm x 21 cm)

PRINT RUN
10,000

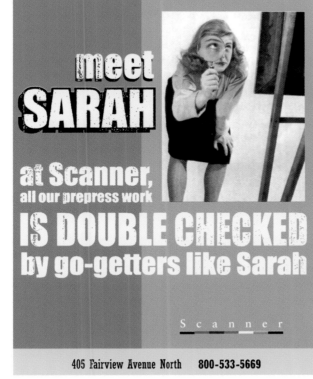

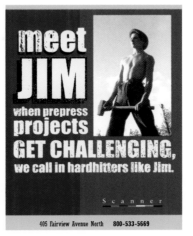

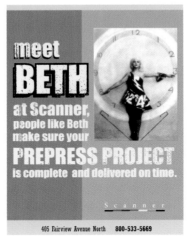

<

SCANNER AD CAMPAIGN

DESIGNERS AT BELYEA NEEDED TO FIND some images that would be perfect for Scanner, a client that sells prepress services. "Scanner was not looking to announce anything new with their ad campaign," remembers Patricia Belyea. "They simply wanted a corporate campaign where readers would perceive them as friendly and professional."

The result: a campaign that turns three fictitious employees into movie stars with artwork that is reminiscent of movie posters from the 1940s and 1950s. The color palette is derived from the saturated colors predominant in the 1940s; the copy and broken type—and headlines set using the font Impact—further reinforce the look and feel of posters from Hollywood's bygone era.

BOTTOMS UP PRINT ADVERTISEMENT

HOUSE INDUSTRIES, A FONT HOUSE, requested this artwork for an issue of *House* magazine, which commemorated the release of their Simian font, inspired by Ed Benguiat's logo for the original *Planet of the Apes* film.

"Milo and this stuff called Grape Juice Plus both come from the third *Planet of the Apes* film, *Escape From the Planet of the Apes,* in which the apes come via space-ship from the future to present day America. Although Milo is inadvertently killed in the first scene, the other two apes are treated as the toast of the town, and the female ape, Zira, finds she has a taste for wine. 'What is it?' she asks. 'Grape juice plus' she is told by one of her human guests. So I turned to liquor ads of the early 1970s for further inspiration, creating this mock-ad for Uncle Milo's Grape Juice Plus, which is rife [with] unseemly double entendre," says Shawn Wolfe.

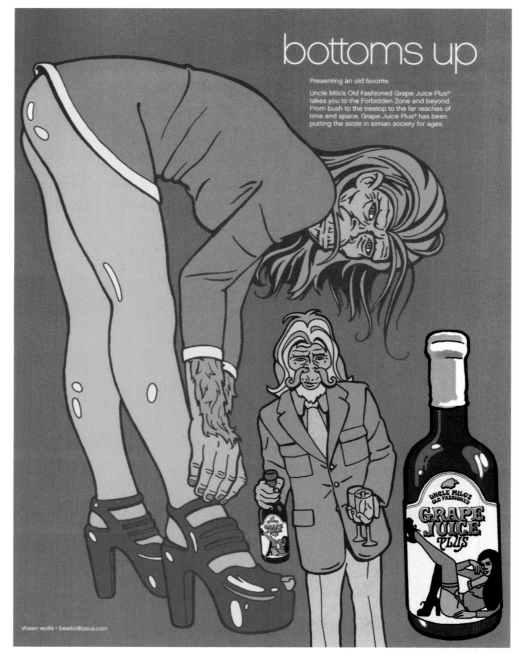

STUDIO
Shawn Wolfe Company

DESIGNER/ILLUSTRATOR
Shawn Wolfe

CLIENT
House Industries

SOFTWARE
Adobe Photoshop

COLORS
4-color process

SIZE
8$\frac{1}{2}$" x 11" (22 cm x 28 cm)

"I think my source of inspiration was what Terence McKenna referred to as the 'ambient world moment,' which is the conditions under which we are all living at any given time. Pop culture, politics, biology…all the forces that are continually converging to produce the conditions of life. So I look to the news, to art, film, literature, fashion, history…everything and anything feeds into this ambient world moment. Artists and filmmakers have been doing this for decades, at least.

"Perhaps design, as it makes the transition from a craft or a trade to what is now considered another form of personal expression, now must look beyond the client and the product and the package and consider larger issues as sources of inspiration."

— S H A W N W O L F E

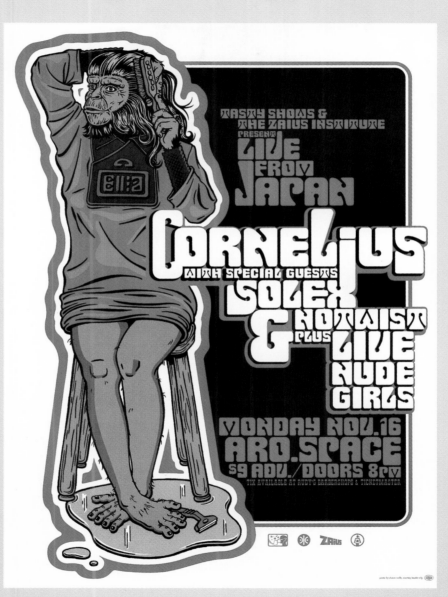

"THIS RIDICULOUS IMAGE APPEARED ON a poster and handbill promoting a live appearance of the hugely popular Japanese rock star, Cornelius, whose associates in the Japanese fashion underworld are responsible for the amazing Bathing Ape clothing line," says Shawn Wolfe."Cornelius took his name from the character from the original *Planet of the Apes* film.

The illustration shows a handsome looking clean-shaven lady ape who appears to be getting ready for a night on the dance floor. The artist and his fans have seen every possible recycling of *Planet of the Apes* imagery known to man. I only hoped to create an ape-inspired image that had not, to the best of my knowledge, been attempted."

STUDIO
Shawn Wolfe Company

DESIGNER/ILLUSTRATOR
Shawn Wolfe

CLIENT
Tasty Shows

SOFTWARE
Adobe Photoshop, FreeHand

SIZE
17$\frac{1}{2}$" x 23$\frac{1}{4}$" (44 cm x 59 cm)

>

MOULIN ROUGE TEASER POSTER

FINE ART INFLUENCED THE OVERALL layout of Mike Salisbury's poster promoting the Nicole Kidman film *Moulin Rouge* (2001), but individual elements came from one of history's greatest films: *Gone With the Wind* (1939). The collage-style layout, colors, and type positioning—which was digitally manipulated—combine to make a poster that looks very avant-garde and, like the film, full of passion.

[SOURCE OF INSPIRATION]

■ *Gone with the Wind* **(1939) Victor Fleming, director**

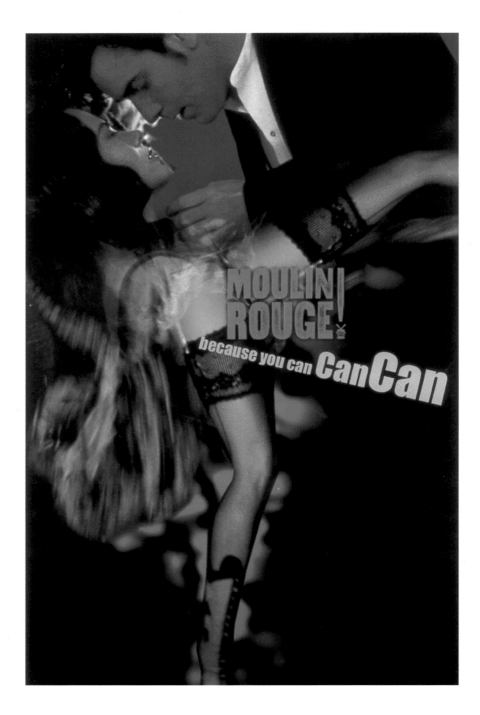

STUDIO
Mike Salisbury, LLC

ART DIRECTOR
Mike Salisbury

DESIGNER
Anja Doering

CLIENT
Twentieth Century Fox

SOFTWARE
QuarkXPress, Adobe Photoshop, Adobe Illustrator

COLORS
4-color process

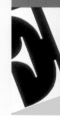

STUDIO
Mike Salisbury LLC

ART DIRECTOR/DESIGNER
Mike Salisbury

ILLUSTRATOR
PowerHouse

PHOTOGRAPHER
Steve Harvey

CLIENT
MGM

COLORS
1-color

SIZE
25" x 39" (64 cm x 99 cm)

<

DEAD OF WINTER POSTER

MIKE SALISBURY MODELED THIS POSTER promoting the 1987 film *Dead of Winter* after Saul Bass's poster for the 1950 film *No Way Out.* Bass conjured up a feeling of terror by setting the title in bold type on a black background with only two small photos in the background. Salisbury's poster was later imitated for the Gene Hackman–Danny DeVito film, *Heist* (2001).

[SOURCE OF INSPIRATION]

■ **Saul Bass, graphic designer (1920–1996) Bass become the rage of Hollywood for his title sequences, including those for** *Psycho* **(1960),** *North by Northwest* **(1959),** *Vertigo* **(1958), and** *West Side Story* **(1961).**

> BEAUTYSPY™ MEDIA KIT AND ANIMATED FLASH INTRO

BEAUTYSPY, A COSMETICS RETAILER THAT sells its wares from a bricks-and-mortar store in Germany and a virtual shop on the Internet, is personified by a special agent who travels around the world searching for the best in beauty products. She is the female James Bond as depicted by designers at enki NY, who looked to the famous fictional spy for inspiration when developing the animated Flash introduction to the Web site. Specifically, they emulated Maurice Binder's title sequence for the first Bond film, *Dr. No*, which premiered in 1962.

"We liked the way Binder makes colored circles dance to the soundtrack because we were already using circles as a graphic device in other Beautyspy collateral," says Lana Le, designer. "As the idea developed, the circles became criss-crossing spotlights, allowing the viewer to catch glimpses of our heroine—even spy on her—until she is finally revealed when the searchlights converge at the end of the animated sequence.

Designers used Beautyspy's branding colors of gold, powder blue, and hot pink for the piece. The colors keep the branding strong and look current, while still playing to the 1960s theme.

[SOURCES OF INSPIRATION]

- Style magazines such as *Printemps*
- *Dr. No* (1962) Terrence Young, director
- *Mission: Impossible* (1996) Brian DePalma, director
- *Austin Powers* (1999) Jay Roach, director

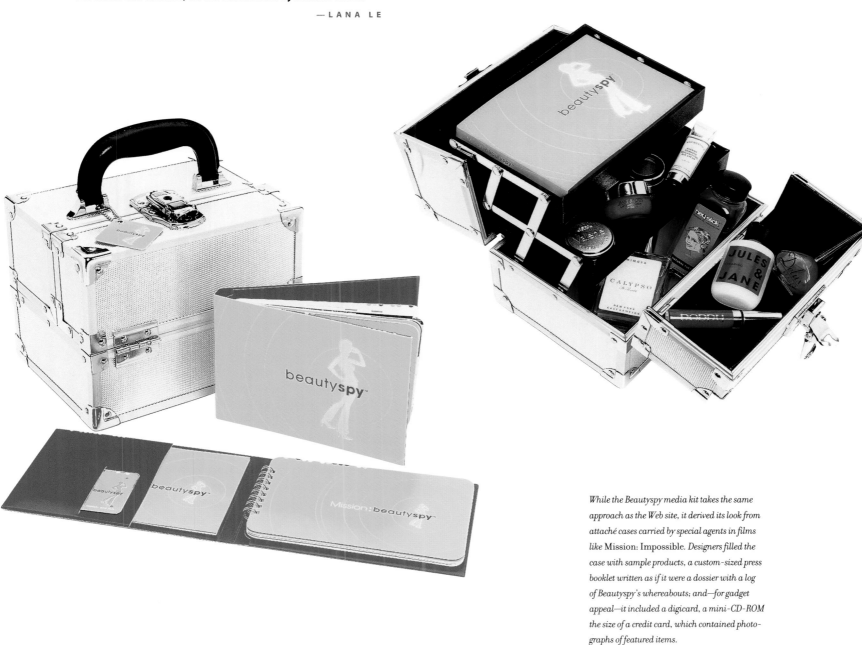

"We went to the video store and had a James Bond marathon.

For colors and attitude, we were influenced by Austin Powers."

— LANA LE

STUDIO
enki NY

ART DIRECTORS/DESIGNERS
Rosanne Kang, Lana Le

ILLUSTRATOR
Lana Le

CLIENT
Beautyspy

SOFTWARE
Adobe Illustrator, QuarkXPress,
Macromedia Flash

PAPER
Strobe Lustro Dull Cover 120 lb.

COLORS
Media Kit 4-color process, plus 3
PMS colors, Flash Intro RGB
matches of 3 PMS colors

PAGES
20

SIZE
6.8" x 4.9" (18 cm x 13 cm)

PRINT RUN
500 per language

COST PER UNIT
$120.00 U.S. for entire media kit
(including beauty case, product
samples, PR booklet, digicard,
and product insert)

While the Beautyspy media kit takes the same approach as the Web site, it derived its look from attaché cases carried by special agents in films like Mission: Impossible. *Designers filled the case with sample products, a custom-sized press booklet written as if it were a dossier with a log of Beautyspy's whereabouts; and—for gadget appeal—it included a digicard, a mini-CD-ROM the size of a credit card, which contained photographs of featured items.*

THIS IS THE 9TH ISSUE IN THE SEARCH FOR UTOPIA. ADAMS/MORIOKA EXPOSE THE SECRET DESIRES OF A HAIRDRESSER TO THE STARS AND THE TRUE MEANING OF UTOPIA, L.A. STYLE. UTOPIA IS A LINE OF COATED PAPERS...

>

APPLETON UTOPIA OVERSIZED BOOKLET

THE FILM VERSION OF JACQUELINE Susann's steamy 1960s novel about drugs and alcohol, *Valley of the Dolls*, provided the inspiration for this oversized booklet promoting Appleton Papers' Utopia One paper stock. "The assignment was to find a hairdresser and use a quote of their idea of Utopia. Big hair and Hollywood led us to reproduce key scenes from *Valley of the Dolls*," says Sean Adams. "The connection between celebrity, the Hollywood myth, designer celebrity and hair was the inspiration."

[SOURCES OF INSPIRATION]

■ *Valley of the Dolls* (1967) Mark Robson, director
■ Cindy Sherman, American photographer (born 1954)

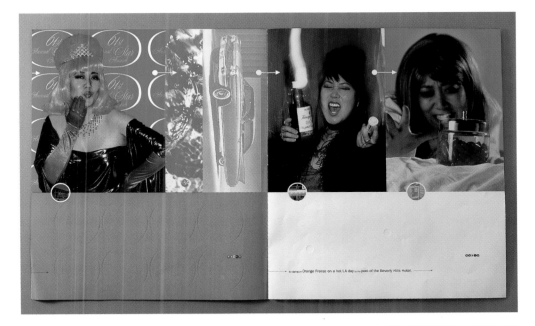

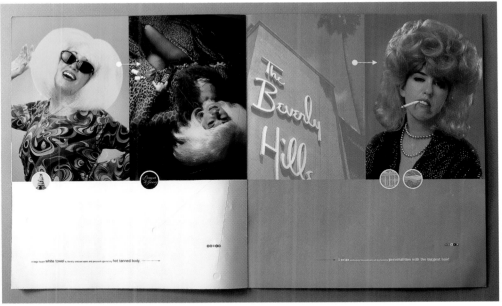

The humor is offbeat and the spreads are dynamic. Traditional four-color process printing is augmented with a fluorescent color palette that brightens and intensifies the color, especially that of the big hair worn by the models—which, thankfully, is provided by a wardrobe of outrageous wigs.

STUDIO
AdamsMorioka, Inc.

ART DIRECTOR
Sean Adams

DESIGNERS
Sean Adams, Noreen Morioka

PHOTOGRAPHER
Hervé Grison

CLIENT
Appleton Papers

SOFTWARE
Adobe Photoshop, Adobe Illustrator, Adobe PageMaker

PAPER
Utopia One

COLORS
4-color process, 2 PMS fluorescents, and varnish

PAGES
12

SIZE
12" x 14" (30 cm x 36 cm)

> **MASSIVE ATTACK HANDBILL**

THIS HANDBILL PROMOTES A LIVE
appearance of the British pop group
Massive Attack. Shawn Wolfe credits his
inspiration to both *Godzilla* movies and
other genre films in which technology
turns on man. "The thousand foot tall
Salaryman seems to be having a massive
heart attack, brought on apparently by
these communication satellites that have
descended from their orbits and are now
buzzing about like biplanes around King
Kong in the finale of that film," says Wolfe.

The illustration was penciled and
inked before Wolfe scanned it into the
computer where he colored it in Photo-
shop. The block football lettering was
drawn in FreeHand.

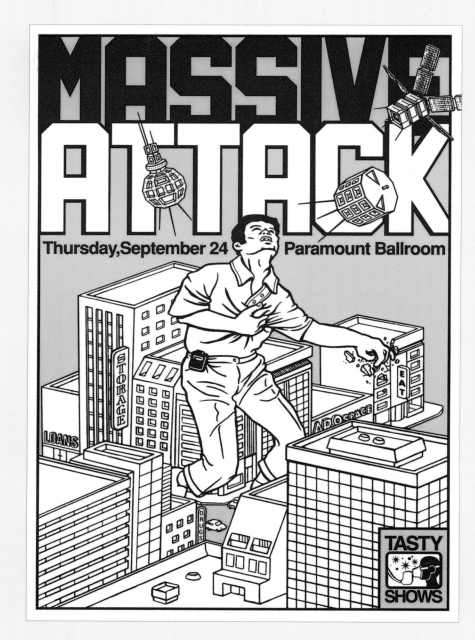

STUDIO
Shawn Wolfe Company

DESIGNER/ILLUSTRATOR
Shawn Wolfe

CLIENT
Tasty Shows

SOFTWARE
Adobe Photoshop, FreeHand

COLORS
2

SIZE
5" x 7" (13 cm x 18 cm)

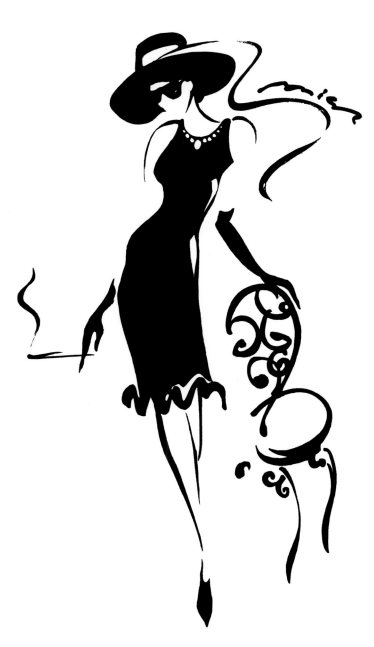

THE LITTLE BLACK DRESS

TO PROMOTE A FASHION SHOW, MISHA Lenn created a hand-drawn sketch, using his stylized brush and ink technique. "It shows the charm of time and lightness of movements," says Lenn, and brings to mind the image of Audrey Hepburn as Holly Golightly in the film *Breakfast at Tiffany's*. The logo was created for the Lasell Institute for Fashion Technology located in Newton, Massachusetts.

[SOURCES OF INSPIRATION]

- *Breakfast at Tiffany's* (1961) Blake Edwards, director
- *Singin' in the Rain* (1952) Stanley Donan and Gene Kelly, directors

STUDIO
Misha Design Studio

ART DIRECTOR/ILLUSTRATOR
Misha Lenn

CLIENT
Lasell Institute for Fashion Technology

> LYON & LYON ADVERTISING CAMPAIGN

BECAUSE LYON & LYON IS A LOS Angeles-based law firm, designers at Greenfield/Belser opted to go with a movie poster theme, apropos to the firm's natural environment. Using a play on words, they chose to depict the lawyers at Lyon & Lyon as true lions with a salute to the ultimate lion movie, *Born Free*.

"It underscored, in a humorous, appealing way, how aggressive they could be when protecting their clients' intellectual property rights," says Burkey Belser.

[SOURCES OF INSPIRATION]

- *Born Free* (1966) James Hill, director
- National Gallery of Art, Washington DC (www.nga.gov)

To achieve they look they were after, designers invested considerable time and effort in the type treatment, incorporating Palatino, Phaeton and Helvetica Condensed into the design. Moreover, they digitally manipulated the type in Photoshop to create the illusion of space and movement, as if the lion were walking out of the type.

STUDIO
Greenfield/Belser Ltd.

ART DIRECTOR
Burkey Belser

DESIGNER
Tom Cameron

COPYWRITER
Lise Anne Schwartz

CLIENT
Lyon & Lyon

SOFTWARE
QuarkXPress, Adobe Illustrator, Adobe Photoshop

PAPER
Gloss text

COLORS
4-color process

>
TIRE GIRLS

THE OLD BUSBY BERKELEY MUSICALS OF
the 1930s provided the inspiration for this
West cover for the magazine of the *Los
Angeles Times*. The campy look was just
right for the piece, according to Salisbury,
who also points out that Fredericks of
Hollywood created the costumes.

[SOURCE OF INSPIRATION]

■ **Busby Berkeley musicals of the 1930s**

STUDIO
Mike Salisbury, LLC

ART DIRECTOR/DESIGNER
Mike Salisbury

CLIENT
West magazine

COLORS
4-color process

SIZE
Tabloid

<

RED GLOVES: "ALL THAT JAZZ" SERIES

BOB FOSSE'S AUTOBIOGRAPHICAL production *All That Jazz* inspired this artwork promoting a theatrical production in Russia. Illustrator Misha Lenn was impressed with Fosse's energy and talent and attempted to convey those attributes in this watercolor.

[SOURCE OF INSPIRATION]

■ *All That Jazz* (1979) Bob Fosse, director

STUDIO
Misha Design Studio

ILLUSTRATOR
Misha Lenn

CLIENT
Theater in Moscow, Russia

>
MOHAWK JUXTAPOSITIONS

"THIS PIECE IS A COMPARISON TOOL showing how images and colors print on the four different whites of white and two textures in the Mohawk Satin and Vellum lines of paper. Generally, these comparison pieces reproduce the same exact image on several stepped pages," explains Allison Williams of Design: MW.

"We have taken a cinematic approach to the photography, using imagery reminiscent of film stills. At times, serial images shot under the same lighting conditions are shown on subsequent pages. These are similar enough to use as a comparison, but the subtle shifts of position turn the book into a narrative experience. Die cuts are interspersed throughout the pages, forming juxtapositions to facilitate comparisons between types of paper."

[SOURCES OF INSPIRATION]

- **Cinema verité, a style of filmmaking brought about by French film directors in the 1960s that emphasized portraying reality**
- **Dogma 95 films, movies created by a collective of film directors in Copenhagen committed to eliminating illusion in movies**

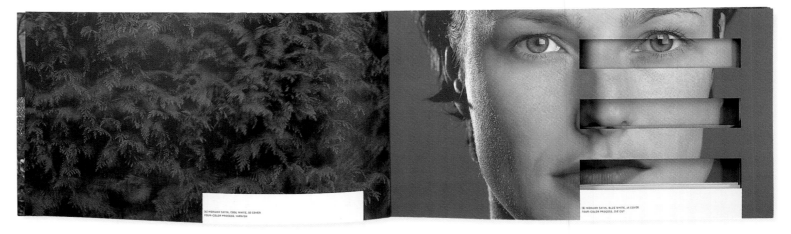

[8A] MOHAWK SATIN, BLUE WHITE, 65 COVER
FOUR-COLOR PROCESS, DIE CUT

[8B] MOHAWK SATIN, COOL WHITE, 80 COVER
FOUR-COLOR PROCESS, VARNISH, DIE CUT

[8A] MOHAWK VELLUM, COOL WHITE, 80 TEXT
FOUR-COLOR PROCESS, METALLIC SILVER, METALLIC GRAY

[8B] MOHAWK SATIN, WARM WHITE, 80 TEXT
FOUR-COLOR PROCESS, METALLIC SILVER, METALLIC GRAY, VARNISH

STUDIO
Design: MW

ART DIRECTORS
Mats Hakansson, JP Williams,
Allison Williams

DESIGNER
Mats Hakansson

PHOTOGRAPHER
Blommers + Schumm

CLIENT
Mohawk Paper Mills

PAPER
Mohawk Satin & Vellum

COLORS
6

PAGES
32

SIZE
13$^1/_4$" x 7$^1/_4$" (33.5 cm x 18.5 cm)

> ## MOVIN' ON LEVI'S TELEVISION COMMERCIAL

LOOKING FOR A CREATIVE WAY TO express movement in a television advertisement for Levi's jeans, Mike Salisbury turned to Fellini's *Casanova*. Two commercials were produced, both in a watercolor style. One was shot with the cast running across sheets of black plastic covered with loose metallic sparkles; a wind machine blew the plastic into billowy forms like waves.

[**SOURCES OF INSPIRATION**]

■ *Casanova* (1976) Federico Fellini, director
■ *King Kong* (1933) Merian C. Cooper and Ernest B. Shoedsack, directors

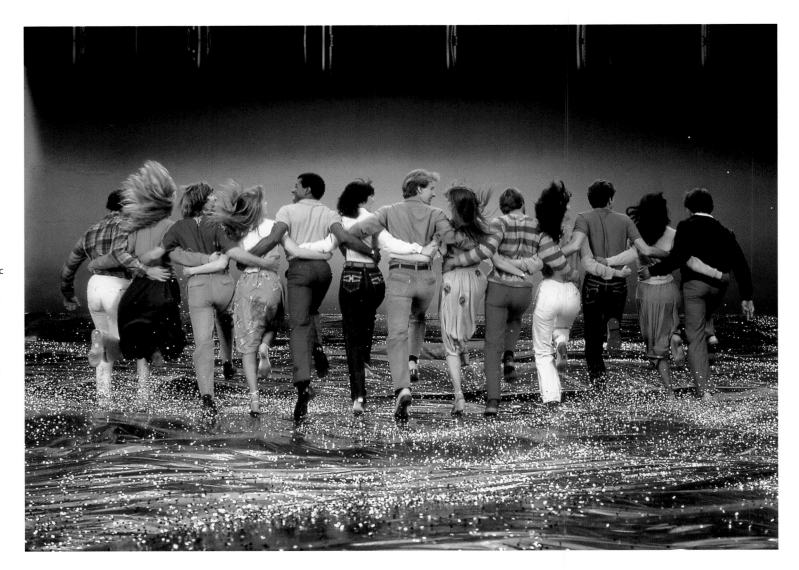

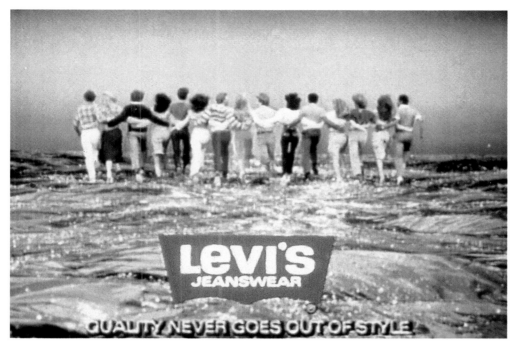

STUDIO
Mike Salisbury, LLC

ART DIRECTOR/DESIGNER
Mike Salisbury

ILLUSTRATOR
Bill Reiser

PHOTOGRAPHER
Norman Gieff

CLIENT
Levi's

COLORS
4-color process

>

MY FAVORITE THINGS BOOKLET

WHEN ONE HEARS STRAINS FROM THE song "My Favorite Things," it is difficult not to conjure up images of Julie Andrews as Maria, singing the popular ballad in *The Sound of Music*—which was exactly what AdamsMorioka intended when designing this pocket-sized self-promotional piece.

The cover typography, which was drawn in Adobe Illustrator, is based on the logo from the record-breaking musical. Inside are graphic representations of "My Favorite Things," which, Sean Adams believes, involves viewers in the piece. They can also sing along by following visual clues to the lyrics.

[SOURCES OF INSPIRATION]

- *The Sound of Music*, (1965) Robert Wise, director
- *James Rosenquist: The Early Pictures, 1961–1964* by Judith Goldman

"How can anyone resist Austria, kids, Julie Andrews, and singing?"

— SEAN ADAMS

STUDIO
AdamsMorioka, Inc.

ART DIRECTOR
Sean Adams

CLIENT
AdamsMorioka, Inc.

SOFTWARE
Adobe Photoshop, Adobe Illustrator, Adobe PageMaker

PAPER
Appleton Utopia One Silk Text 80 lb.

COLORS
4-color process

PAGES
24

SIZE
5-1/4" x 4" (13.5 cm x 10 cm)

PRINT RUN
1000

COST PER UNIT
$2.00 U.S.

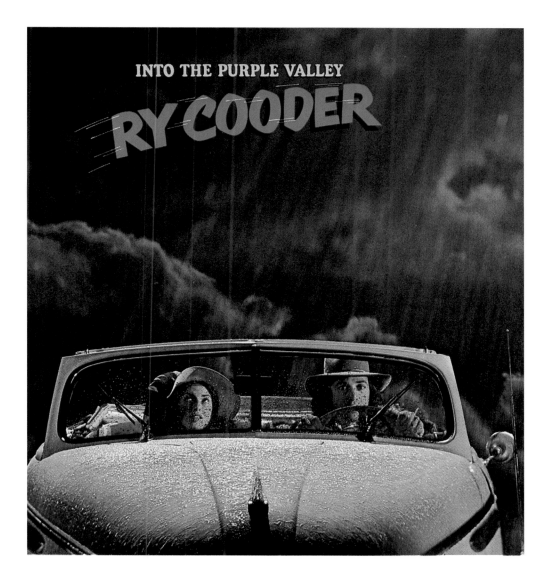

RY COODER MUSIC POSTER

STUDIO
Mike Salisbury, LLC

ART DIRECTOR
Mike Salisbury

DESIGNERS
Mike Salisbury, Dave Bhang

PHOTOGRAPHER
Mary Evans

CLIENT
Ry Cooder

COLORS
4-color process

THE 1934 ACADEMY AWARD-WINNING film *It Happened One Night,* starring Clark Gable and Claudette Colbert, provided the perfect inspiration for this artwork. The hand-lettered piece pays tribute to the romantic comedy, which tells the story of a couple who manage to make their way from Florida to New York by bus, by foot, by hitchhiking, and eventually by "borrowing" an old jalopy.

[SOURCE OF INSPIRATION]

■ **It** *Happened One Night* **(1934) Frank Capra, director**

[COMPILATION OF INSPIRATIONS]

Tap into the top-recommended creative inspirations from the contributors to this book. Browse the online galleries, books and periodicals that have led to dynamic design solutions in the past, and perhaps something you see will trigger your own creativity, as well.

MUSEUMS AND ART COLLECTIONS
- California Museum of Photography, Riverside, California (www.cmp.ucr.edu)
- Dallas Museum of Art, Dallas, Texas (www.dm-art.org)
- E.G. Bührle Collection, Zurich, Switzerland (www.buehrle.ch)
- Galleria Civica di Modena, Italy (www.comune.modena.it)
- George Eastman International Museum of Photography and Film, New York (www.eastman.org)
- Guggenheim Museum, New York (www.guggenheim.org)
- J. Paul Getty Museum, Los Angeles (www.getty.edu/museum)
- Kimbell Museum, Fort Worth, Texas (www.kimbellart.org)
- Le Louvre, Paris (www.paris.org/Musees/Louvre)
- Metropolitan Museum of Art, New York (www.metmuseum.org)

- Museum of Fine Arts, Boston (www.mfa.org)
- National Gallery of Art, Washington DC (www.nga.gov)
- National Portrait Gallery (www.npg.si.edu)
- San Diego Museum of Art (www.sandiegomuseum.org)
- Santa Barbara Museum of Art (www.sbmuseart.org)
- Serpentine Gallery (www.serpentinegallery.org)
- Tate Gallery, London (www.tate.org.uk)
- The Art Institute of Chicago (www.artic.edu)
- The Museum of Modern Art (MoMA), New York (www.moma.org)
- The Museum of Television & Radio, New York (www.mtr.org)
- The Rachofsky House, Dallas, Texas
- The State Hermitage Museum, St. Petersburg, Russia (www.hermitagemuseum.org)
- Van Gogh Museum, Amsterdam (www.vangoghmuseum.nl)
- ZKM Karlsruhe (Museum for Multimedia Art, Karlsruhe, Germany)

INTERNET SITES
- Academy of Motion Picture Arts and Sciences (www.oscars.org)

- All Movie Guide (www.allmovie.com)
- All Posters (www.allposters.com)
- American Movie Classics (www.amctv.com)
- Artcyclopedia (www.artcyclopedia.com)
- Barewalls.com (www.barewalls.com)
- Interesting.com (www.interesting.com)
- Internet Movie Database (www.imdb.com)
- Movie Trailers Database (www.comingsoon.com)
- Orazio Centaro's art images on the web (www.ocaiw.com)
- Postershop.com (www.postershop.com)
- Salon.com (www.salon.com)
- Stockart.com (www.stockart.com)
- The Society of Illustrators (www.societyillustrators.org)

BOOKS AND MAGAZINES
- *1,001 Advertising Cuts from the Twenties and Thirties* compiled by Leslie Cabarga, Richard Greene and Marina Cruz

- *100 Years of Posters* by Bevis Hillier
- *1800 Woodcuts by Thomas Bewick and His School* by Blance Cirker
- *American Roadtrip* by Jeff Brouw
- *Basquiat* by Richard Marshall, Robert Marshall, and Robert D. Thompson (contributor)
- *Collage* by Herta Wescher
- *Communication Arts Illustration Annual*
- *Contemporary Posters: Design and Techniques* by George F. Horn
- *Dada & Surrealism* by Robert Short
- *Dada, Surrealism, and Their Heritage* by William S. Rubin
- *Decoupage: The Big Picture Sourcebook* edited by Hasbrouck Rawlings
- *Form* magazine (www.form.de)
- *Handbook of Early Advertising Art* by Clarence P. Hornung
- *Harper's Bazaar* magazine
- *Henri Matisse (Getting to Know the World's Greatest Artists)* by Mike Venezia
- *James Rosenquist: The Early Pictures, 1961–1964* by Judith Goldman
- *Matisse on Art (Documents of Twentieth-Century Art)* by Henri Matisse and Jack Flam (editor)
- *Matisse Portraits* by John Klein
- *Metropolis* magazine
- *Modern Art: Painting, Sculpture,*

Achitecture by Sam Hunter and John Jacobus

- *Music, A Pictorial Archive of Woodcuts & Engravings* by Jim Harter
- *René Magritte* by A.M. Hammacher
- *Rolling Stone* magazine
- *Saul Steinberg Commentary* by Harold Rosenberg
- Style magazines such as *Printemps*
- *Supersonic Swingers* by Shag
- *The Catalogue* by Saul Steinberg
- *The Clip Art Book* by Gerald Quinn
- *The Conran Directory of Design* by Stephen Bayley
- *The History & The Collection* by Sam Hunter
- *The Illustrators (The British Art of Illustration 1800–2001)*, Chris Beetles Limited
- *The Inspector* by Saul Steinberg
- *The Labyrinth* by Saul Steinberg
- *The New World* by Saul Steinberg
- *The Smithsonian* magazine
- *Une Semaine de Bonté: A Surrealistic Novel in Collage* by Max Ernst
- *Wallpaper* magazine, Time, Inc.

When you need a quick creative mentor, look to these artists and experts for inspiration. You can find their works in various books or magazines, or online.

ARTISTS
- Arp, Hans (Jean Arp), German French dadaist (1887–1966)
- Bartolozzi, Salvador, Spanish artist
- Basquiat, Jean-Michel, American artist (1960–1988)
- Calder, Alexander, American artist (1898–1976)
- Caravaggio, Italian artist (1573–1610)
- Cassandre, A.M., French commercial artist (1901–1981)
- Chagall, Marc, Russian-French painter and stained glass artist (1887–1985)
- Chia, Sandro, American artist (born 1946)
- Cornell, Joseph, American artist (1903–1972)
- Crawford, Ralston, American precisionist painter (1906–1978)
- da Vinci, Leonardo, Italian artist (1452–1519)
- Davis, Stuart, American painter (1892–1964)
- de Goya, Francisco, Spanish romantic painter and printmaker (1746–1828)
- Duchamp, Marcel, French-American artist (1887–1968)

- Fonesca, Caio, American artist (born 1959)
- Frasconi, Antonio, Argentinean artist (born 1919)
- Groesbeck, Dan Sayre, American painter and illustrator (1879–?)
- Hausmann, Raoul, Austrian dadist (1886–1971)
- Hohlwein, Ludwig, German artist (1874–1949)
- Johns, Jasper, American abstract painter (born 1930)
- Judd, Donald, American sculptor (1928–1994)
- Klee, Paul, Swiss expressionist artist (1879–1940)
- Kngwarreye, Emily Kane, Australian Aboriginal artist (1910–1996)
- Lea, Tom, American artist (1907–2001)
- Ligon, Glenn, African-American artist (born 1960)
- Magritte, René, Belgium surrealist artist (1898–1967)
- Man Ray/Emmanuel Rudnitsky, American surrealist (1889–1976)
- Matisse, Henri, French impressionist artist (1869–1954)
- McCall, Robert T., American artist
- Moholy-Nagy, László, Hungarian artist and photographer (1895–1946)
- Monet, Claude, French impressionist artist (1840–1926)

- Picasso, Pablo, Spanish painter and sculptor (1888–1973)
- Rosenquist, James, American artist (born 1933)
- Shag (Josh Agle), American artist (www.shag-art.com)
- Shahn, Ben, Lithuanian-American social-realist artist (1898–1969)
- Sheeler, Charles, American precisionist artist and photographer (1883–1965)
- Thurston, Randal, American artist
- Toulouse-Lautrec, Henri French artist (1864–1901)
- Van Camp, Dorothea, American artist (www.unit35.com)
- Van Gogh, Vincent, Dutch artist (1853–1890)
- Von Buhler, Cynthia, American artist (www.cynthiavonbuhler.com)
- Vostell, Wolf, German artist (1932–1998)
- Warhol, Andy, American pop artist (1928–1987)

PHOTOGRAPHERS
- Hurrell, George, Hollywood photographer (1904–1992) (www.hurrellphotography.com)
- Moholy-Nagy, László, Hungarian painter and photographer (1895–1946)

>

>

- Pocock, Mary, American photographer (www.keylight.org)
- Sheeler, Charles American precisionist painter and photographer (1883–1965)
- Sherman, Cindy, American photographer (born 1954)

ILLUSTRATORS

- Audubon, John James, American naturalist and illustrator (1785–1851)
- Edelmann, Heinz, Czech artist, illustrator, and graphic designer (born 1934)
- Groesbeck, Dan Sayre, American painter and illustrator (1879–?)
- Irvin, Rea, illustrator for The New Yorker (1881–1972)
- Penagos, Rafael de, Spanish illustrator (1889–1954)
- Posada, José Guadalupe, Mexican engraver (1852–1913)
- Pyle, Howard, American illustrator (1853–1911)
- Rockwell, Norman, American illustrator (1914–1999)
- Steinberg, Saul, Romanian-American illustrator (1914–1999)
- Toulouse-Lautrec, Henri, French artist (1864–1901)
- Wright, Frank Lloyd, American architect (1869–1959)

GRAPHIC DESIGNERS

- Albers, Joseph, German-American designer (1888–1976)
- Bass, Saul, graphic designer (1920-1996)
- Chwast, Seymour, American graphic designer (born 1931)
- Edelmann, Heinz, Czech artist, illustrator, and graphic designer (born 1934)
- Glaser, Milton, American graphic designer (born 1929)
- Vignelli, Massimo, Italian-American designer (born 1931)

[contributors]

ADAMSMORIOKA, INC.
370 S. Doheny Drive #201
Beverly Hills, CA 90403
www.adamsmorioka.com

ALR DESIGN
3007 Park Avenue #1
Richmond, VA 23221
www.alrdesign.com

ART DIRECTION + DESIGN
Am Bopserveg 1B
Stuttgart, D 70184
Germany
www.kimmerle.de

BARBARA BROWN MARKETING & DESIGN
2873 Pierpont Blvd.
Ventura, CA 93001
www.bbmd-inc.com

BELYEA
1809 Seventh Avenue, Suite 1250
Seattle, WA 98101
www.belyea.com

BRAUE BRANDING & CORPORATE DESIGN
Eiswerkestrasse 8
27572 Bremerhaven
Germany
www.brauedesign.de

CPD – CHRIS PERKS DESIGN
333 Flinders Lane, Level 2
Melbourne, Victoria 3000
Australia
www.cpdtotal.com.au

CROSS COLOURS
P.O. Box 47098
Parklands 2121
South Africa

DESIGNHELDEN
Glümerstrasse 14
76185 Karlsruhe
Germany
www.designhelden.de

EMMA WILSON DESIGN COMPANY
500 Aurora Avenue N.
Seattle, WA 98109
www.emmadesignco.com

ENKI NY
636 Broadway, Suite 707
New York, NY 10012
www.enkiny.com

FOSSIL
2280 N. Greenville Avenue
Richardson, TX 75082
www.fossil.com

GREENFIELD/BELSER LTD.
1818 N Street, NW, Suite 110
Washington, DC 20036
www.gbltd.com

GRETEMAN GROUP
1425 E. Douglas, Suite 200
Wichita, KS 67211
www.gretemangroup.com

GROUP BARONET/THE MARLIN CO.
2200 N. Lamar #201
Dallas, TX 75202
www.groupbaronet.com

HENDERSON BROMSTEAD ART
105 West Fourth Street
Winston-Salem, NC 27101
www.hendersonbromstead.com

HORNALL ANDERSON DESIGN WORKS INC.
1008 Western Avenue, Suite 600
Seattle, WA 98104
www.hadw.com

KENZO IZUTANI OFFICE CORPORATION
1-24-19 Fukasawa Setagaya-Ku
Tokyo 158-0081
Japan
www.izutanix.com

LIKOVNI STUDIO
Dekanici 42, Kerestinec
10 431 Sveta Nedelja
Croatia
www.list.hr

MOD/MICHAEL OSBORNE DESIGN
444 De Haro Street, Suite 207
San Francisco, CA 94107
www.modsf.com

MIKE SALISBURY, LLC
P.O. Box 2809
Venice, CA 90294
Email: mikesalisbury@mediaone.net

MIRKO ILIC CORP.
207 E. 32nd Street
New York, NY 10016
212-481-9737

MISHA DESIGN STUDIO
1638 Commonwealth Ave., Suite 24
Boston, MA 02135
www.mishalenn.com

>

>

LOWRY STUDIO
1116 N. French Street
Santa Ana, CA 92701
www.janicelowry.com

PACIFICO
99 Almaden Boulevard, Suite 900
San Jose, CA 95113
www.pacifico.com

PALAZZOLO DESIGN STUDIO
6410 Knapp
Ada, MI 49301
www.palazzolodesignstudio.com

PRIMO DESIGNS
101 Fifteenth Sreet
San Francisco, CA 94103
www.primo.com

SEYMOUR CHWAST/THE PUSHPIN GROUP
18 East Sixteenth Street
New York, NY 10003
www.pushpininc.com

Q30 DESIGN INC.
489 King Street, W., Suite 400
Toronto, ON M5V 1K4
Canada
www.q30design.com

THE RIORDON DESIGN GROUP INC.
131 George Street
Oakville, ON L6J 3B9
Canada
www.riordondesign.com

SHAWN WOLFE CO.
104 14th Ave. East F
Seattle, WA 98112
www.shawnwolfe.com

SOMMESE DESIGN
481 Glenn Road
State College, PA 16803
LxS14@psu.edu

SQUIRES & COMPANY
2913 Canton Street
Dallas, TX 75226
www.squirescompany.com

STOLTZE DESIGN
49 Melcher Street
Boston, MA 02210
www.stoltze.com

STUDIO GT&P
Via Ariosto, 5
06034 Foligno, PG
Italy
www.tobanelli.it

TAU DISEÑO
Felipe IV, 8
Madrid 28014
Spain
www.taudesign.com

TERRAPIN GRAPHICS
991 Avenue Road
Toronto, ON M5P 2K 9
Canada
www.terrapin-graphics.com

TRICKETT & WEBB LIMITED
84 Marchmont Street
London WC1N 1RD
England
www.trickettandwebb.co.uk

TURNER DUCKWORTH
164 Townsend Street, #8
San Francisco, CA 94107
www.turnerduckworth.com

WILLOUGHBY DESIGN GROUP
602 Westport Rd.
Kansas City, MO 64111
www.willoughbydesign.com

2CDESIGN
3303 Lee Parkway, 5th Floor
Dallas, TX 75219
www.2cdesign.com

[COPYRIGHT AND PERMISSIONS] ←